Historic England

Dorset

Andrew Jackson

AMBERLEY

First published 2020

Amberley Publishing
The Hill, Stroud, Gloucestershire, GL5 4EP
www.amberley-books.com

The publisher is grateful to the staff at Historic England
who gave the time to review this book.

All contents remain the responsibility of the publisher.

ISBN 978 1 3981 0137 1 (print)
ISBN 978 1 3981 0138 8 (ebook)

British Library Cataloguing in Publication Data.
A catalogue record for this book is available from the
British Library.

Typesetting by Aura Technology and Software
Services, India. Printed in Great Britain.

Contents

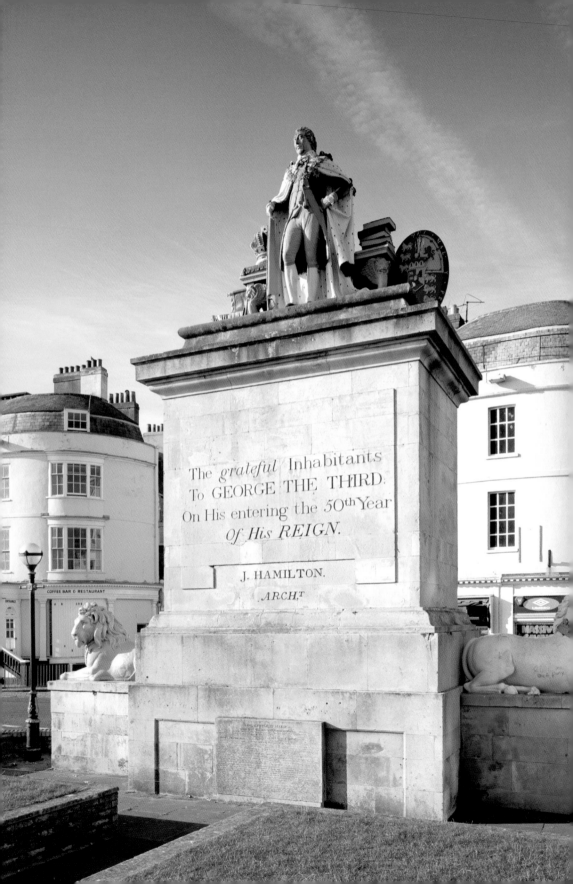

Introduction

Dorset, along with East Devon, can boast of one of the oldest histories in the world in the form of the Jurassic Coast. This area of international significance is England's first natural World Heritage Site, putting it on a par with the likes of the Grand Canyon and the Great Barrier Reef.

The Jurassic Coast stretches a distance of 95 miles from Old Harry near Studland to Lyme Regis, and beyond into East Devon as far as Orcombe Point near Exmouth. Its fossils and rocks provide us with a visible record of life 185 million years ago, and the nature of the coast lends itself to some spectacular formations such as Old Harry Rocks, Lulworth Cove and Durdle Door to name but a few.

Dorset also boasts a rich history involving ancient man, which is apparent in the amazing array of ancient sites ranging from the late Neolithic period, through the Bronze Age, to the Iron Age. These early remains are scattered throughout the county, but the vicinity on or near the South Dorset Ridgeway, south-west of Dorchester, has a particularly rich abundance, and is considered to be an area of international archaeological importance equivalent to Stonehenge.

The threads of history can be further traced through Roman, Saxon and Norman times and beyond, via numerous castles and churches and many other buildings of significance.

Dorset has been the stage for various historical events over the years, not least of which was the Monmouth Rebellion of 1685, which started at Lyme Regis and subsequently saw the county pay a horrifyingly heavy price, as the feared and loathed Judge Jeffreys wrought shocking and violent retribution during the Bloody Assizes.

In more recent years Dorset hosted thousands of American troops preparing for D-Day before they left from the ports of Weymouth, Portland and Poole on their perilous mission to spearhead the attack on Omaha Beach.

Dorset is a predominantly rural county renowned for dairy farming, particularly in the lush meadows of the Blackmore Vale, where thousands of cows can be seen in pastoral scenes not too dissimilar to that which Thomas Hardy's fictional milkmaid, Tess of the D'Urbervilles, would have encountered in the late nineteenth century.

Indeed, nobody captured the essence of Dorset's rural heritage better than Hardy, whose novels also captured the harsh privations of the farm labourer, which were all too apparent as stark reality in the appalling plight of the Tolpuddle Martyrs.

Dorset is a county full of outstanding natural beauty, both on the coast and inland, and one could even go as far as to describe it as God's own county. It has certainly been endowed with its fair share of saints, and it is said that on one occasion Jesus even paid a visit to assist with a carpentry project.

Jurassic Coast

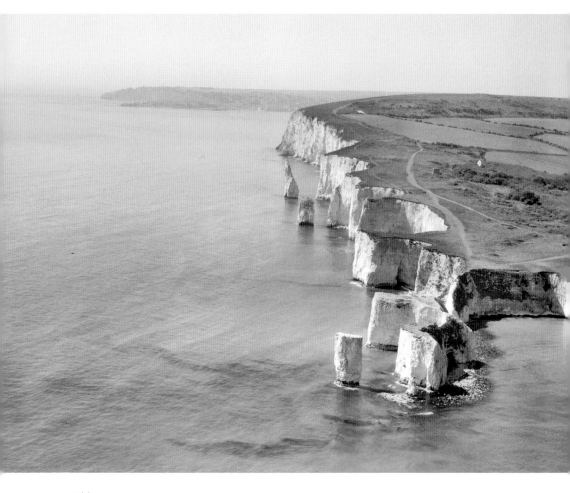

Old Harry

185 million years of the Earth's history are represented by 95 miles of the Dorset and East Devon coast. This coastline is England's only natural World Heritage Site and is considered globally important for understanding the science of our planet.

The site runs from Old Harry near Studland in the east to Exmouth, Devon, in the west, and contains a complete record through the Cretaceous, Jurassic and Triassic periods. The rocks dip towards the east, with the oldest being in the west and the youngest in the east.

Each geological layer tells its own story of ancient deserts, tropical seas or dinosaur-infested swamps, and the effects on the rocks coupled with the effects of erosion by the sea have produced some wonderful coastal features with unique character.

'Old Harry' is a chalk stack standing in the sea at Handfast Point on the Isle of Purbeck. It is named after Harry Paye, who was Poole's most notorious pirate. The stack marks the Jurassic Coast's most easterly point, and Old Harry to Durlston Country Park at Swanage encompasses the Cretaceous period of 145–165 million years ago, which is the youngest section of the Jurassic Coast. (© Historic England Archive. Aerofilms Collection)

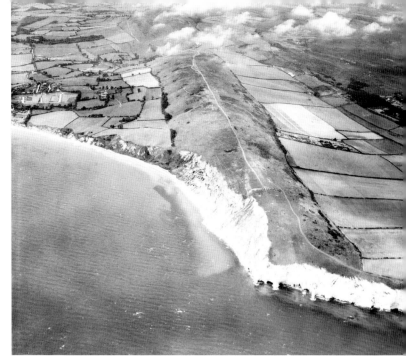

Ballard Point, Ballard Cliff and Ballard Down
The next headland moving westwards along the Jurassic Coast is Ballard Point. (© Historic England Archive. Aerofilms Collection)

North-east view over the North End of Swanage Beach with Ballard Down and Ballard Cliffs in the Distance
In this area the rocks are 65 million years old, but 35 million years ago the chalk was tilted to form a ridgeway, which runs from Ballard Down, north of Swanage, through Corfe Castle to Lulworth, and under the sea to the Needles on the most western tip of the Isle of Wight. This huge fold is the most northerly part of a process which also formed the Alps.

At Swanage, the soft sandstone and Wealden clay deposited from an ancient river delta has been washed away to form the perfect bay. (© Historic England Archive)

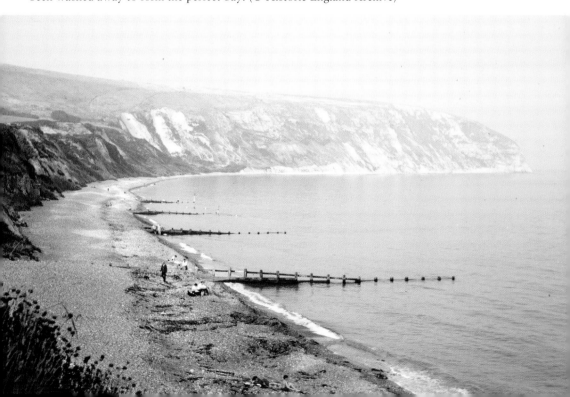

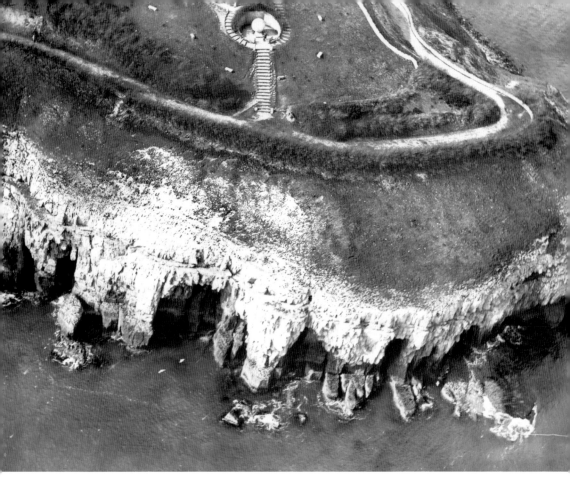

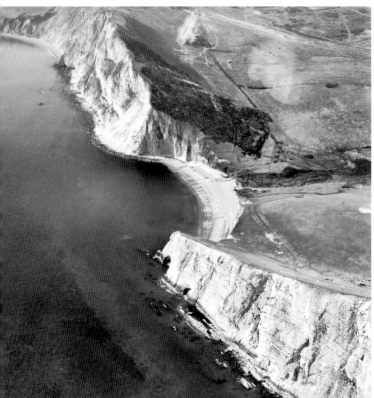

Above: Durlston Head
The cliffs here consist of thinly bedded Purbeck strata, which mark the junction between the Cretaceous and Jurassic period, and the stretch of coastline between Durlston Head and St Aldhelm's Head has some spectacular features such as Dancing Ledge. Others such as Winspit and Tilly Whim Caves are man-made quarries (see Industry/Quarrying in the Purbecks, p. 76).

This image also features the Great Globe, which is part of the Durlston Castle estate (see Castles). (© Historic England Archive. Aerofilms Collection)

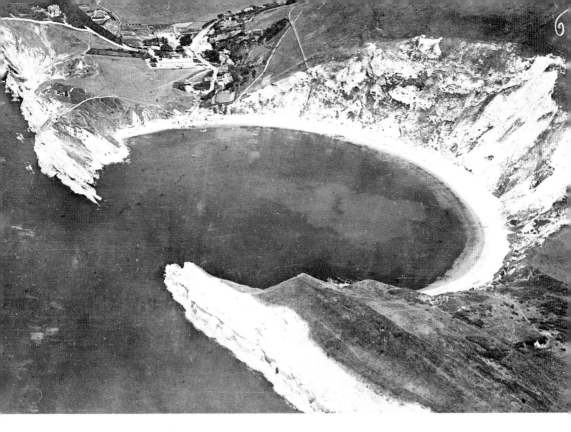

Above: Lulworth Cove

Lulworth Cove is an almost perfect semicircular cove, cut out of the soft sands and clays of the Cretaceous Wealden Beds.

Towards the end of the Jurassic period and the start of the Cretaceous period, sea levels dropped and, just west of the cove, a fossil forest grew consisting of tree stumps over which the surrounding algae fossilised.

Later dinosaurs marauded through an arid landscape of salt flats, and then towards the end of the Cretaceous period sea levels rose again forming a huge thickness of white chalk. (© Historic England Archive. Aerofilms Collection)

Opposite below: Moving Westwards to Arish Mell

The locale between St Aldhelm's Head and Lulworth Cove, particularly around Kimmeridge, features some of the most important geology on the Jurassic Coast, and the dark Kimmeridge clay here dates from the Jurassic period. It was formed at the bottom of a tropical sea, 156–158 million years ago, during a period known to geologists as the Kimmeridge Stage.

Harder ledges stretch out to sea from the beach, and the underlying rocks are formed of Kimmeridge shale, which has been commercially drilled since 1959, producing up to eighty barrels of oil a day. Just west of Kimmeridge is Hobarrow Bay, a small secluded beach with an oil shale and shingle beach.

A feature called Long Ebb protrudes from the headland. It is formed by a flat dolomite bed that reappears at Kimmeridge as Broad Bench, as well as places west of Hobarrow Bay.

Continuing further west we come to Arish Mell, Worbarrow Bay and Mupe Cove, which are formed from the relatively soft Cretaceous rocks that were deposited in river deltas and shallow seas.

The steep-angled layers of rock that exist between here and Lulworth are known as the 'Lulworth Crumple', and are a result of sedimentary folding, caused by collisions of the continental plates of Africa and Europe 30 million years ago. The image shows Arish Mell from the air. (© Historic England Archive. Aerofilms Collection)

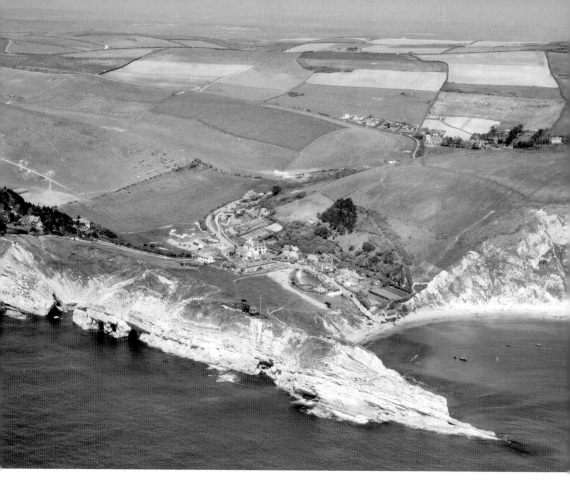

Stair Hole
Just to the west of Lulworth Cove is Stair Hole, where the Lulworth Crumple can be seen most vividly in a series of swirly patterns in the rocks – a bit like a crazy spiral staircase descending to the sea. This aerial image incorporates West Point, Stair Hole and the village of West Lulworth. (© Historic England Archive. Aerofilms Collection)

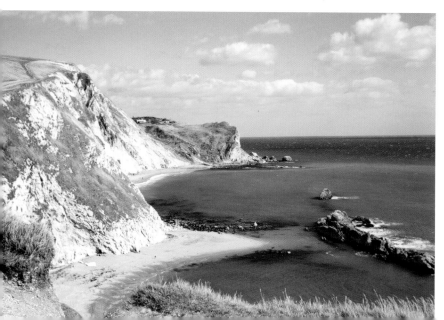

Man o' War Cove
At the western end of Man o' War Cove the exposed beds of rock are almost vertical, as this cove is also affected by the Lulworth Crumple. (© Historic England Archive)

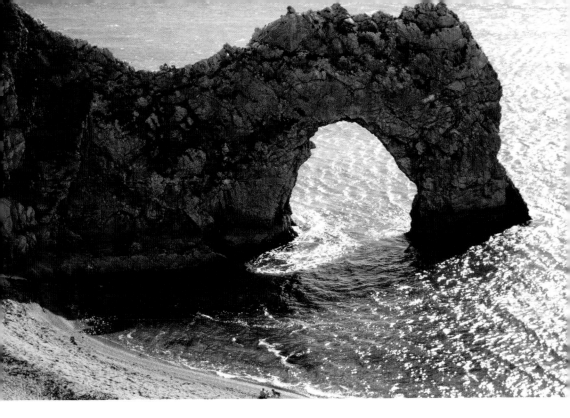

Above: Durdle Door
Durdle Door is one of Dorset's most iconic landmarks. It is a natural arch formed from the Portland and Purbeck limestone, which are thin in this area, and steeply dipping and folding. (© Historic England Archive)

Below: Weymouth Beach
Moving westwards from Durdle Door, the next major coastal feature is Weymouth Beach. (© Historic England Archive)

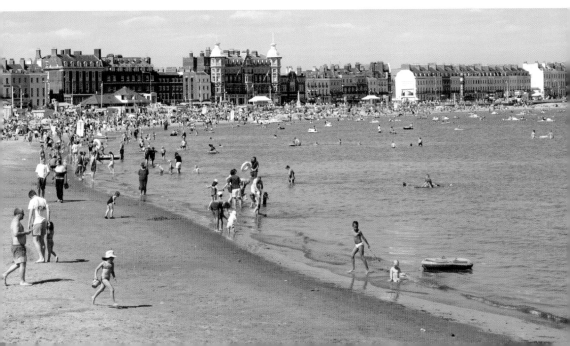

Above: Portland Bill
The limestone rocks of the Portland peninsular dip gently towards the sea, and the raised beach at Portland Bill, which is above the current sea level, shows where the original sea level was during the Pleistocene period. The image shows Portland Bill Lighthouse, which, in various guises for 300 years, has warned against the treacherous Portland Race currents and Shambles Bank. (© Crown copyright. Historic England Archive)

Below and opposite above: View of Castletown on the Isle of Portland and along Chesil Beach
The famous Portland limestone, from which half of London is built, is around 145 million years old and dates to the end of the Jurassic period, when Portland was a kind of tropical paradise consisting of shallow seas in which ammonites and all manner of marine dinosaurs swam.

Portland is the Jurassic Coast's most southerly point, and is joined to the mainland by the 18-mile-long shingle bar of Chesil Beach. (Historic England Archive; © Historic England Archive)

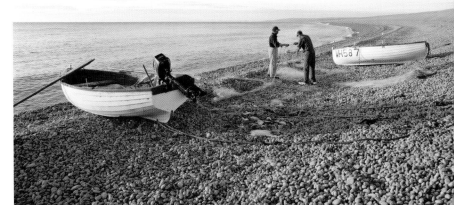

Below: Bridport
Harbour,
West Bay
An aerial view
of Bridport
Harbour,
West Bay.
(© Historic
England Archive.
Aerofilms
Collection)

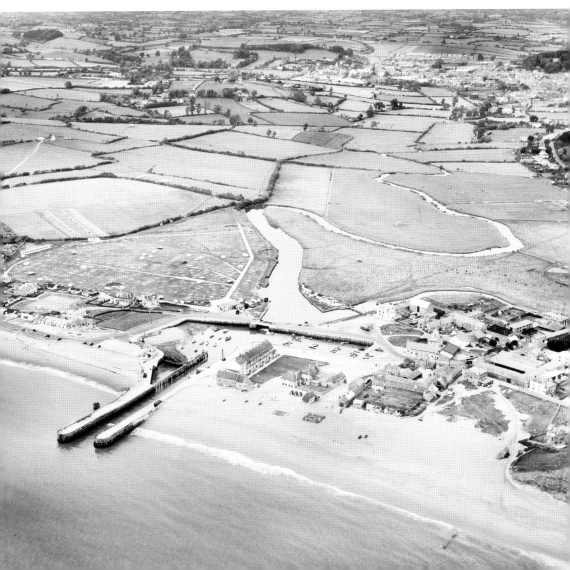

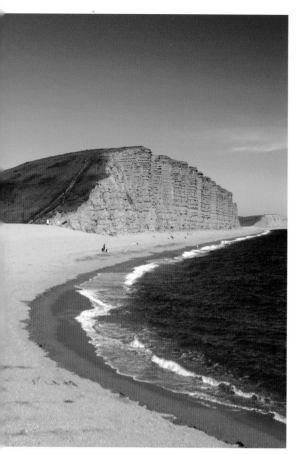 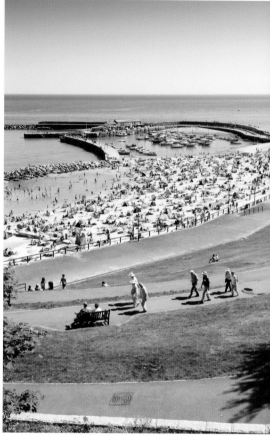

Above left: Beach and Jurassic Coastline at West Bay
The crumbling sandstone cliffs at West Bay were formed due to the falling sea levels of 180 million years ago, as the cliffs were laid down in shallow tropical seas. They are known as Bridport Sands and are part of the Upper Lias division of the early Jurassic period, when Dorset was just north of the tropics. (© Historic England Archive)

Above right: West Bay to Lyme Regis
Just beyond West Bay is the Golden Cap, which, at 7,520 feet, is the highest point on the south coast of England. It has a cap of golden sandstone – hence the name – and the cliffs in this area provide a record of the whole of the Jurassic period.

Moving further west, the beach at Charmouth is formed from Jurassic grey shales and harder limestones that are clearly visible in layers of rock dipping eastwards, and characterised by a feature called the Great Unconformity, which was formed by a younger series of Cretaceous rocks cutting across an older series of Jurassic rocks.

Between Charmouth and Lyme Regis is the Black Ven, which is Britain's most volatile landslide complex, becoming active when heavy rain percolates through the sandstone.

The rocks at Lyme Regis are 200 million years old, and, as at Charmouth, are teeming with fossils, particularly ammonites, which are extinct marine molluscs that were something between a squid and a cuttlefish.

This image shows a scene looking across Langmoor Gardens to Lyme Regis Cobb. (© Historic England Archive)

Ancient Sites

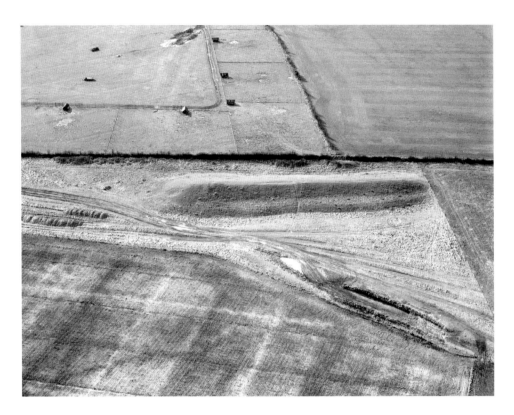

Pimperne Long Barrow

An amazing array of ancient sites, which are thought to range from the late Neolithic period to the early Bronze Age, can be seen throughout Dorset including cursuses, barrows, stone circles and hill forts.

The vicinity on or near the South Dorset Ridgeway, south-west of Dorchester, has a particularly rich abundance of these early remains, and is considered to be an area of international archaeological importance on a par with Stonehenge.

Cursuses are Neolithic structures that are thought to represent some of the oldest prehistoric monuments in Britain. They are large parallel banks that are often aligned with respect to nearby barrows. The Dorset Cursus is one of the best examples in England and consists of two banks around 6 miles long and 300 feet apart. They both span across Cranborne Chase and align with other long barrows in the area, as well as the henge at Knowlton. They have the appearance now of soil or crop marks, but in their day were massive banks.

Various types of barrows are found throughout Dorset, including long barrows, round barrows, bank barrows, bowl barrows, bell barrows, disc barrows and pond barrows. They are thought to be ancient burial mounds. They often occupy prominent positions where they can be seen from a distance and in many cases are clustered around other ancient sites.

Long barrows tended to be built during the early and middle Neolithic periods and were constructed of earth or drystone mounds with ditches. They are among the earliest type of ancient monument readily seen. Pimperne Long Barrow is the longest barrow in England and is a good example of a long barrow. (© Historic England Archive. Aerofilms Collection)

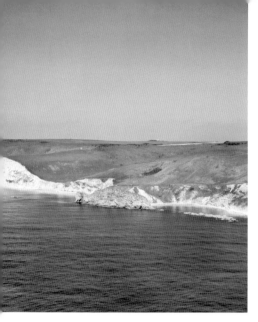

Left: Swyre Head Bowl Barrow

Bowl barrows are steep-sided, flat-topped mounds composed of earth and chalk. They date from the Neolithic period to the late Bronze Age. Swyre Head is just to the west of Durdle Door and is on the left of the image. (© Historic England Archive. Aerofilms Collection)

Below: Winterbourne Abbas Poor Lot Barrow Cemetery

Round barrow cemeteries are thought to date to the Bronze Age. They tend to comprise of groups of up to thirty barrows of different types. They occur throughout Britain, but are particularly prevalent in the South Dorset Ridgeway area, and are often in prominent locations, although this one is unusual in that it is situated in a valley.

This site consists of forty-four barrows of differing types. The largest barrow is a bowl barrow in the centre of the group. (Historic England Archive)

Traced By E. C. Taylor

| BARROWS AT WINTERBORNE POOR LOT | DEED PLAN | Scale -: 1/2500 | MINISTRY OF WORKS ANCIENT MONUMENTS BRANCH LAMBETH BRIDGE HOUSE, S.E.I. | Job No DRG. No |

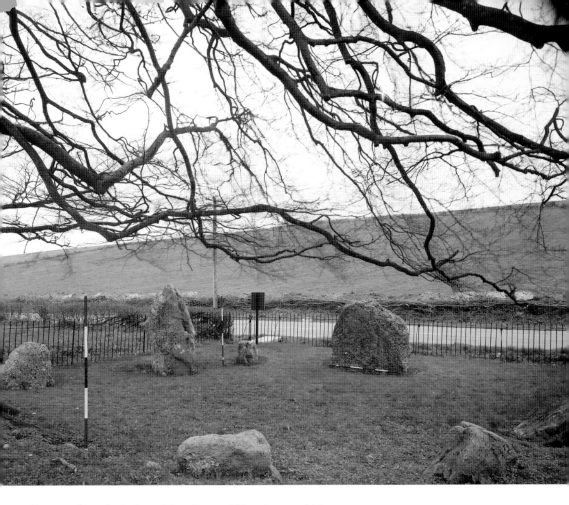

Above and overleaf above: Nine Stones, Winterbourne Abbas

By 3000 BC, barrows, cursuses and other enclosures had ceased to be constructed and instead circular monuments of various types tended to be built, such as henges and stone circles. The purpose of stone circles is shrouded in mystery. Archaeologists postulate that they were used for some sort of ancient ritual, possibly connected with burial. Another theory is that the stones are specifically aligned for astronomical purposes, and worship of the sun, moon and stars. Similarities can be drawn with Stonehenge in this respect. Yet another theory is that the presence of the stones was used to confer status and power upon the residents.

Stone circles are prevalent throughout much of Britain, Ireland and Brittany and are thought to be from the late Neolithic and early Bronze Age over a period between 3000 and 900 BC.

There are nine stone circles in Dorset and they have a tendency to be smaller than those elsewhere. They tend to be made of sarsen stone, apart from the Rempstone Stone Circle, which is made from local sandstone. Rempstone is also the only one not located on the chalk hills south-west of Dorchester.

Kingston Russell Stone Circle, near Abbotsbury, is the largest surviving stone circle in Dorset. The ring consists of eighteen stones and is believed to date to the Bronze Age.

These images show the nine stones of Winterbourne Abbas, which consist of nine irregularly spaced stones, two of which are significantly larger than the others, which is an arrangement inconsistent with other stone circles in Dorset. (Historic England Archive)

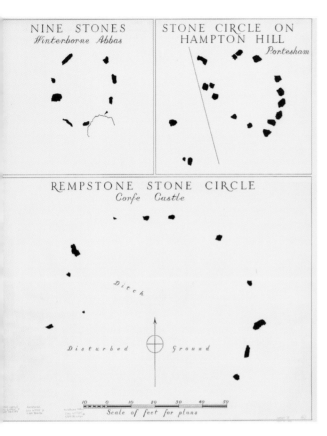

NINE STONES
Winterborne Abbas

STONE CIRCLE ON
HAMPTON HILL
Portesham

REMPSTONE STONE CIRCLE
Corfe Castle

Ditch

Disturbed Ground

10 0 10 20 30 40 50
Scale of feet for plans

Below: Knowlton Church Henge
Henges are circular banks with ditches
inside them, which may contain stone
structures; for example Stonehenge. They
are considered to be ancient ceremonial
sites, dating from 3000 to 2000 BC.

A twelfth-century Norman church is
unusually situated in the middle of this
Neolithic henge, and some believe that it
symbolises the transition from pagan to
Christian worship.

There are quite a few ancient sites near
Knowlton Church Henge dotted around
Cranborne Chase, such as the Northern
Circle, Old Churchyard, Southern Circle
and the Dorset Cursus. The fact that
Cranborne Chase was a royal hunting
ground in Norman times meant that the
land was strictly controlled, meaning
these sites were well preserved.

This image depicts Knowlton Church
Henge as it may have appeared in
Neolithic times. (© Historic England
Archive)

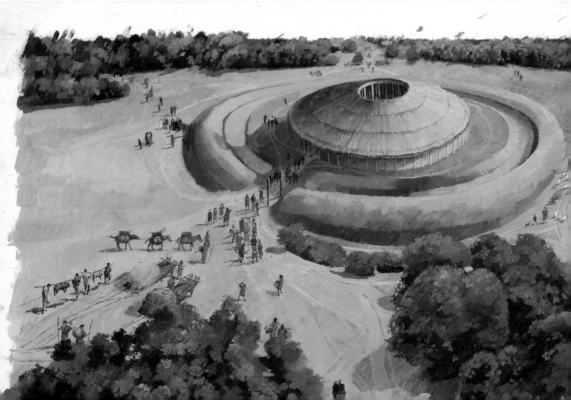

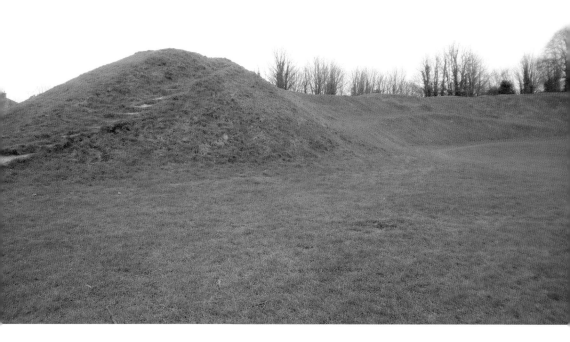

Above and below: Maumbury Rings
Maumbury Rings is a Neolithic henge to the south of Dorchester situated within a park, where excavations in the twentieth century revealed human and deer skulls. The site has been used throughout history. The Romans turned it into an amphitheatre, and then during the Civil War the site was used as a garrison to defend the southern entrance to Dorchester. Later, following the 1685 Monmouth Rebellion and the subsequent Judge Jeffreys-led Bloody Assizes, the site was used as a place of public execution for at least eighty rebels. (Author's collection)

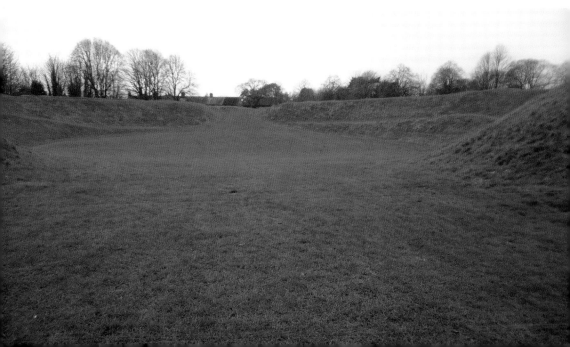

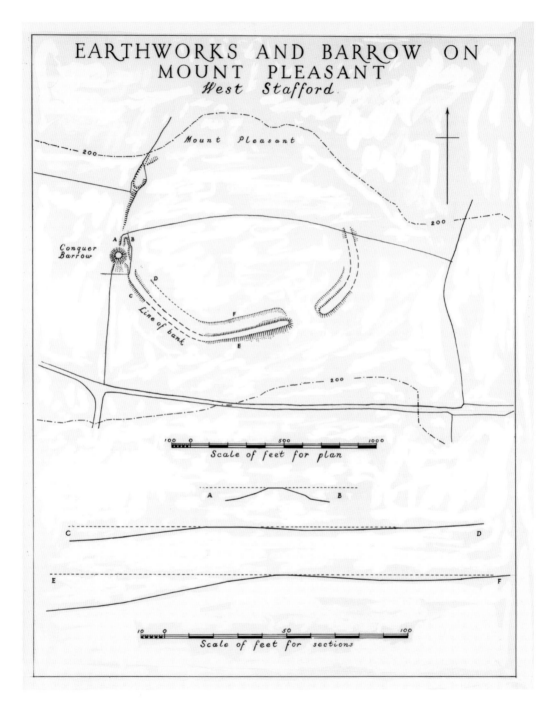

Mount Pleasant
Mount Pleasant at West Stafford is a probable Neolithic henge and barrow. The henge has been largely ploughed out except in its southern arc, but is the best example of a henge in the area of the South Dorset Ridgeway. (Historic England Archive)

A Reconstruction Drawing of the Entrance at Mount Pleasant
A reconstruction drawing showing the massive timber entrance at Mount Pleasant henge, as it may have appeared during the Beaker period (*c.* 2500–1700 BC). (© Historic England Archive; © Crown copyright. Historic England Archive)

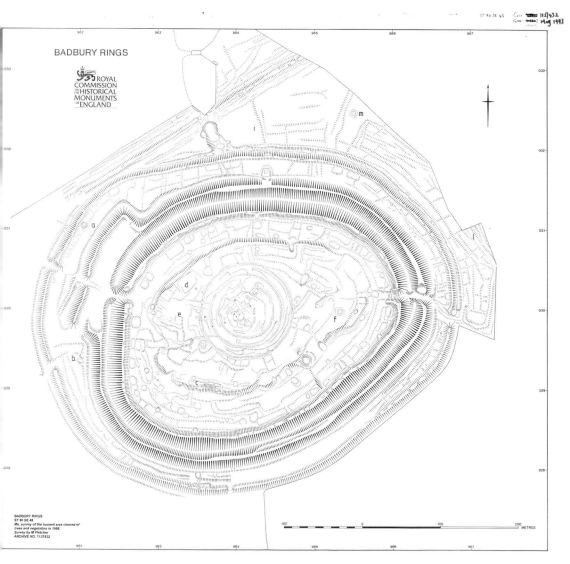

BADBURY RINGS

ROYAL COMMISSION ON THE HISTORICAL MONUMENTS OF ENGLAND

100 0 100 200
METRES

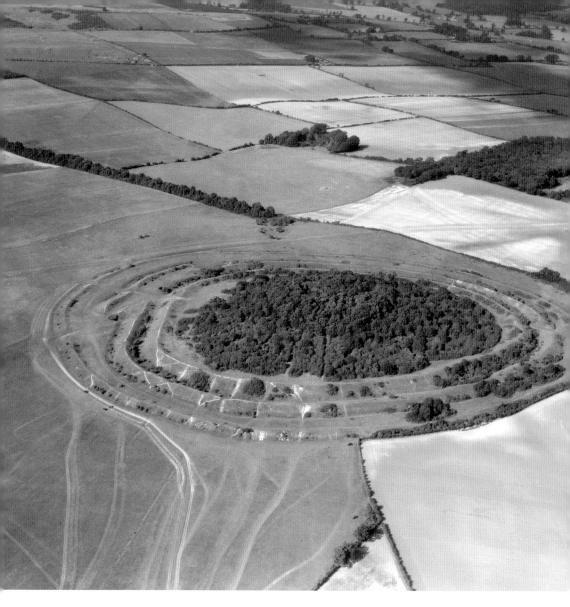

Above and previous page below: Badbury Rings

Badbury Rings is situated near Shapwick between Wimborne and Blandford and consists of an Iron Age hill fort and burial mounds. It dates from 800 BC and was known to be in use until AD 43 during the time of the Roman occupation. A Romano-British settlement called Vindocladia was situated nearby, as well as a Roman temple. There is also a raised section of ground close by that was once the old Roman road from Dorchester to Old Sarum (Salisbury), where ghostly apparitions of Roman legionnaires marching have been reported.

Badbury Rings is part of a series of Iron Age forts in Dorset, which form a route to the Iron Age port of Hengistbury Head. The others in the chain are Hambledon Hill, Hod Hill, Spetisbury Rings and Dudsbury Camp. Many of these became redundant when Maiden Castle later became the premier fort in the area. (© Historic England Archive. Aerofilms Collection)

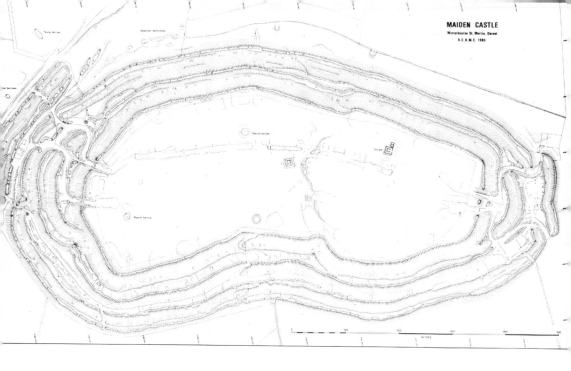

Above: Maiden Castle, Winterborne St Martin
Maiden Castle is one of Europe's largest Iron Age hill forts, mostly built in the fifth century BC. The site has a neolithic enclosure that dates to around 3600 BC. This image shows a survey of the former hill fort. (© Crown copyright. Historic England Archive)

Below: A view of the ramparts of the west entrance. (© Historic England Archive)

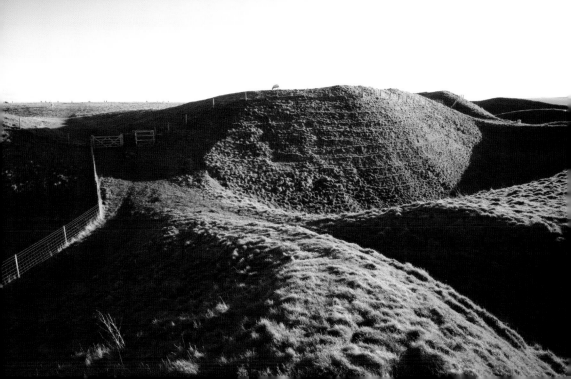

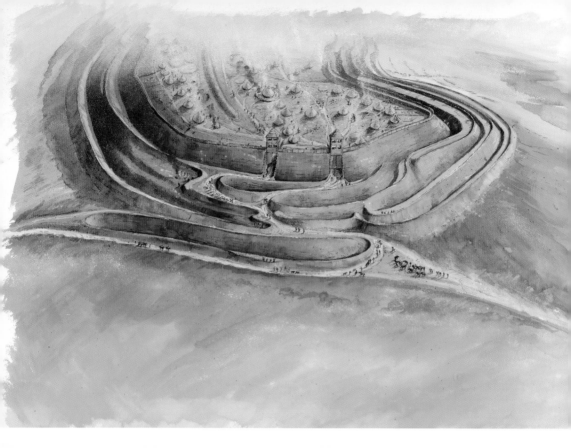

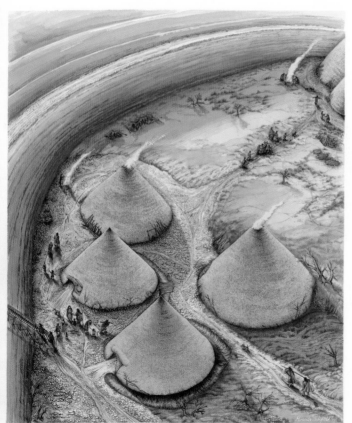

Above: An aerial reconstruction of the west entrance. (© Historic England Archive)

Left: A reconstruction painting showing roundhouses within the fort. (© Historic England Archive)

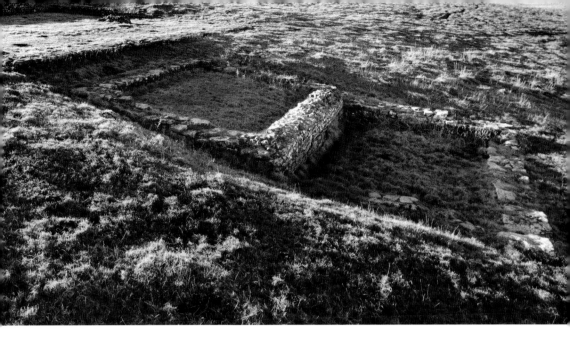

Above: The remains of the house that is believed to have been next to a Romano-British temple in the interior of the fort. (© Historic England Archive)

Below: A reconstruction painting showing the Romano-British temple. (© Historic England Archive)

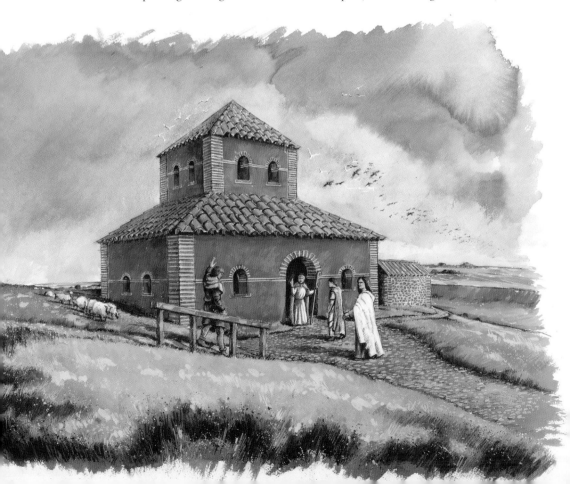

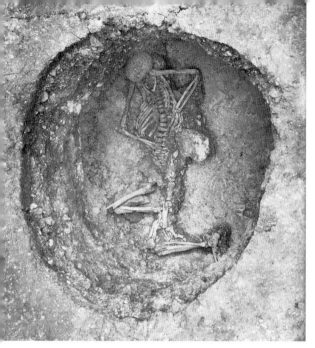

Left: A skeleton found at a burial site. (Historic England Archive)

Below: Abbotsbury Hill Fort
Abbotsbury Hill Fort was an Iron Age fort situated on Wears Hill on the South Dorset Ridgeway. In AD 43 the Romans overwhelmed the resident Celtic Durotriges tribe, before moving on to capture the main prize of Maiden Castle (see Armed Conflict/Maiden Castle, p. 44). (© Historic England Archive. Aerofilms Collection)

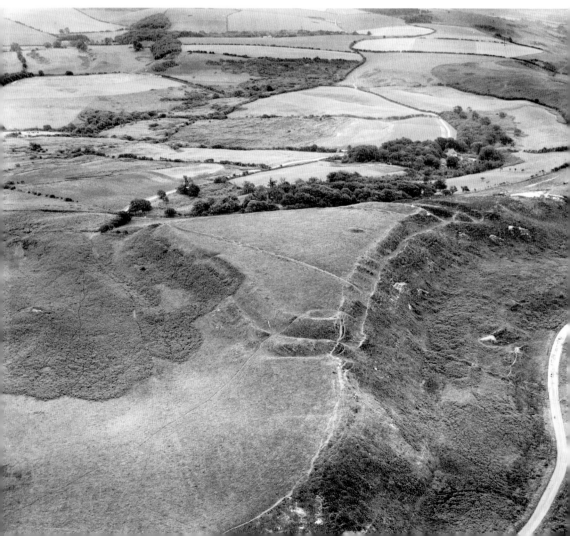

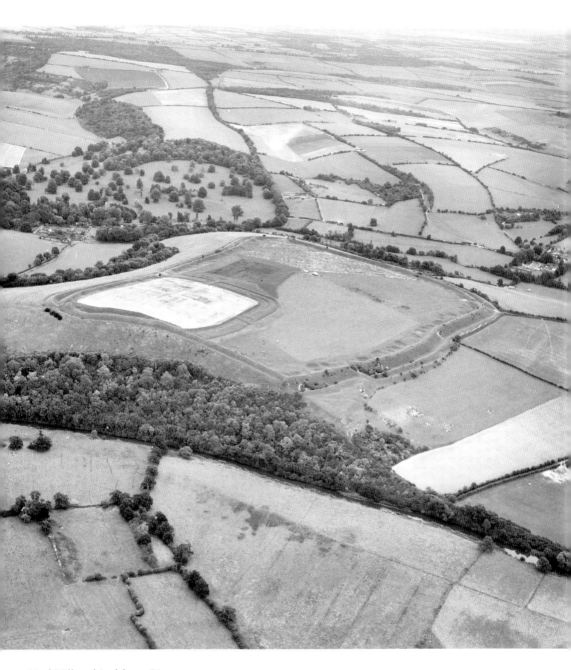

Hod Hill and Lydsbury Rings

Hod Hill is situated adjacent to Hambledon Hill, 3 miles north-west of Blandford within the Blackmore Vale. Inside the fort are the remains of the buildings that were believed to be inhabited by the ancient Dorset Durotriges tribe in the late Iron Age.

The fort was captured in AD 43 by the Roman Second Legion led by Vespasian, who also captured Maiden Castle and other hill forts in the south. The Roman legions remained for five to six years but had gone by AD 50. (© Historic England Archive. Aerofilms Collection)

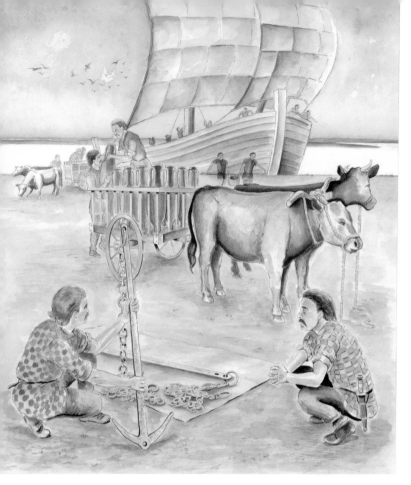

Hengistbury Head
Hengistbury Head, which forms part of the Bournemouth suburb of Southbourne, was an Iron Age port and settlement, dating from 700 BC. Two ditches, or double dykes as they are termed, separated the headland from the mainland. These ditches were constructed in a similar way to those at Maiden Castle. Alfred the Great later rebuilt the harbour to defend against raiders. He also built the nearby town of Twynham, later to become Christchurch. (© Historic England Archive)

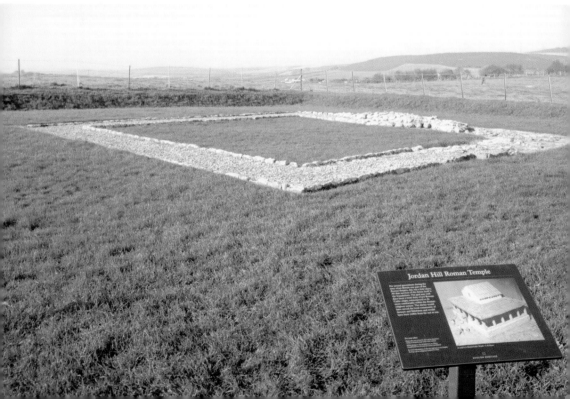

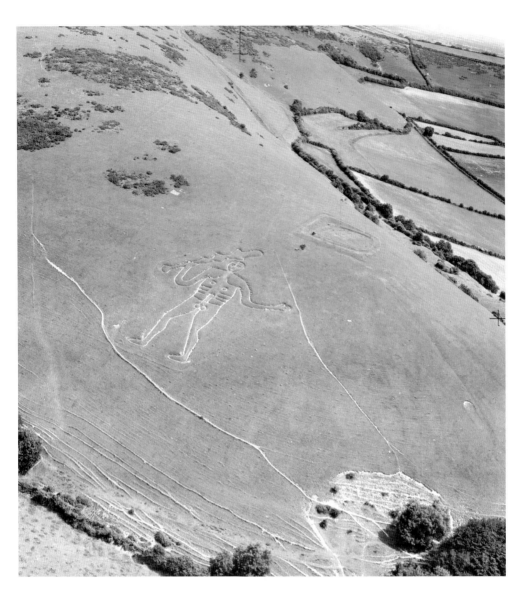

Above: Cerne Abbas Giant
The Cerne Abbas giant is a 180-foot figure cut into the side of a hill known as Giant Hill or Trendle Hill, on top of which is an Iron Age earthwork known as the Trendle or 'Frying Pan'. Some historians believe that the figure is of Saxon origin, whereas others believe it is from the seventeenth century. Local folklore insists that if a woman sleeps on the phallus, she will bear many children. It is also believed that a cure for infertility is for a couple to make love on the phallus. (© Historic England Archive. Aerofilms Collection)

Opposite below: Jordan Hill Roman Celtic Temple
This temple is situated on the South Dorset Ridgeway near Preston, Weymouth. Extensive archaeological excavations have proved that the site was in use from AD 69 to 79 until the end of the fourth century. (© Historic England Archive)

Historical Figures and Events

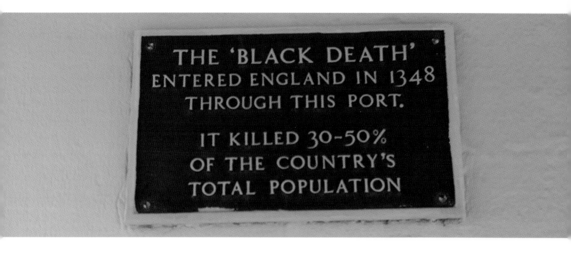

Black Death

One of Dorset's least auspicious moments was the introduction of the Black Death to England. In 1348, a sailor docked at Weymouth carrying the feared bubonic plague, which he had contracted in Gascony in France. The Black Death quickly spread throughout Weymouth before spreading right the way through England and killing half of the population. (Author's collection)

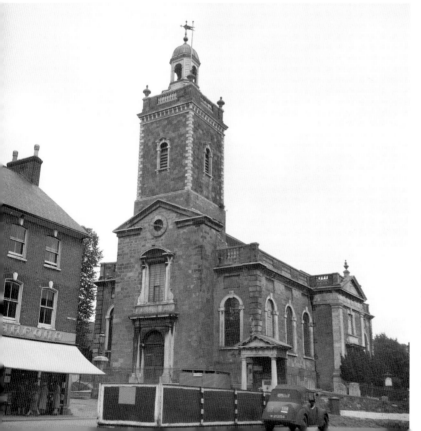

St Peter and St Paul's Church, Blandford Forum
This church was completed in 1739 by the Bastard brothers after the previous one was destroyed in the great fire of Blandford in 1731. It is built predominantly from Portland and Ham Hill stone, and fittingly a memorial to the brothers, John and William, is situated within. They designed many other buildings in Blandford after the fire and then went on to become entrepreneurs and local politicians. (Historic England Archive)

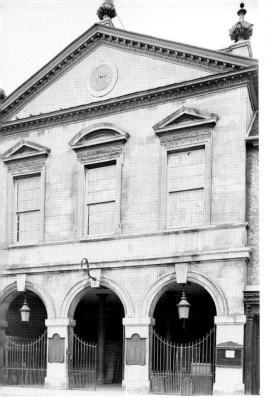
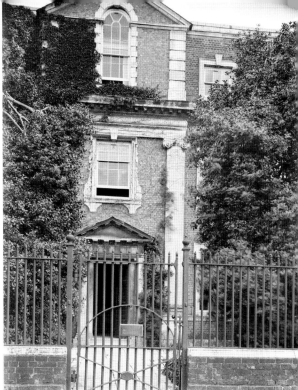

Above left: Town Hall and Corn Exchange, Blandford Forum
This was the first building to be completed after the fire. It has the date 1734 inscribed on the frieze of the centre window and has been signed 'Bastard Architect'. The brothers tended to favour Portland stone with intricate embellishments, and this building is typical of the style they used throughout Blandford. (Historic England Archive)

Above right: Coupar House
This Grade I listed building was also built by the brothers and is now the Blandford British Legion. (Historic England Archive)

Isaac Gulliver's House, Wimborne Minster
Isaac Gulliver (1745–1822) was Dorset's most celebrated and successful smuggler. He was a wanted man after his involvement in a clash with customs officers on the coastline between Bournemouth and Poole. He regularly evaded their attention, and on one occasion was secreted out of the Kings Head in Poole (see Pubs and Hotels), hidden inside a barrel, under the very noses of customs officials. On another occasion he eluded customs men by lying motionless in a coffin with his face covered with white powder as he played dead. He controlled a massive smuggling operation that spread its tentacles across the whole of Dorset and into Devon, Wiltshire and Hampshire.

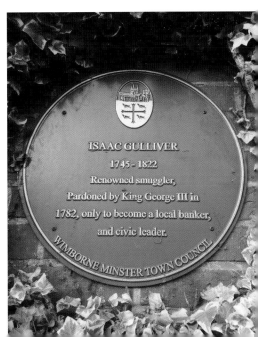

Having amassed a tidy fortune, he retired from smuggling and was given a king's pardon by George III. He became a wine merchant (although it was believed that a large proportion of his wine was of the smuggled variety), banker and civic leader in Wimborne. He is buried in the vault of Wimborne Minster. (Author's collection)

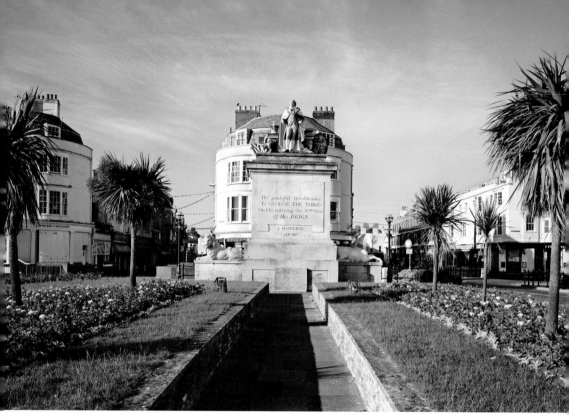

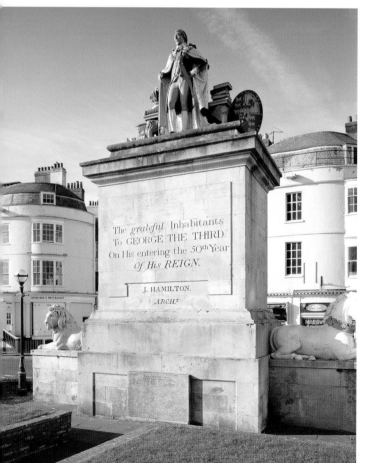

Above and left: King George III Statue, Weymouth

George III reigned from 1760 to 1820. He enjoyed spending as much time as possible relaxing in Weymouth, and in effect invented the seaside holiday. When he first plunged into the sea, he was accompanied on the beach by a bathing machine, enabling him to change in modesty as several fiddlers played 'God Save the King'.

The statue celebrates the fiftieth year of King George III's reign and his patronage of Weymouth. It is opposite what is now the Gloucester Hotel on the Esplanade, which was formerly the Gloucester Lodge, where the king stayed with his brother the Duke of Gloucester. There is also a hill featuring a chalk figure of George III astride a horse on the outskirts of Weymouth at Osmington. (© Historic England Archive)

John Slade

During the seventeenth and eighteenth centuries, hundreds of merchants from Poole sailed across the Atlantic to the cod-rich Grand Banks of Newfoundland. They also took goods and commodities with them that could be exchanged for furs, seal skins and cranberries.

The merchants grew rich, and as a spin-off, Poole as a town also became wealthy, as local businesses and tradesmen really began to focus on the trade. During this period wealthy merchants started building themselves some impressive mansions to signify their wealth and status, in what is now called the Old Town area of Poole.

West End House was built in the early eighteenth century for John Slade, a wealthy Newfoundland merchant. It is a Grade II listed building and a prime example of early Georgian architecture. It dominates St James's Square and overlooks St James's Church in the Old Town quarter. The four stone salt urns and pineapples on top of the façade allude to the source of the family's wealth.

In the nineteenth century the house was owned by Jesse Carter, the founder of Poole Pottery. (Author's collection)

William Spurrier

The land for this house was acquired at Upton, just outside Poole, by William Spurrier, four times mayor of Poole, whose wealth was also gained from the Newfoundland trade.

The house was built by his son Christopher between 1816 and 1818, and its west wing was added in 1825. However the decline of the Newfoundland trade, coupled with Christopher's gambling, forced him to sell the property in 1825 to Sir Edward Doughty, a member of the Tichborne family.

Upton House remained within the Tichborne family until 1901, when spiraling debts resulted in the necessity of a sale to the Llewellins, who held it until 1957. It was then bequeathed to the Borough of Poole, who rented it for several years to Prince Carol of Romania.

However in 1976, public opinion dictated that the estate should be opened as a country park for the benefit of the people of Poole, and eventually in 1981 the doors opened to the public.

In 2015, Upton Country Park became part of the newly established Holes Bay Nature Park, and now features an area of bird hides. (Author's collection)

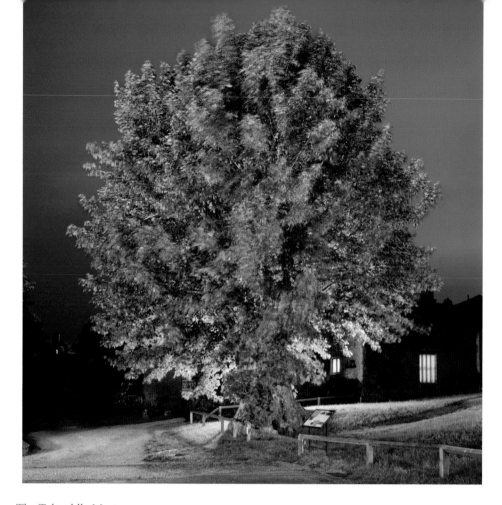

The Tolpuddle Martyrs

The Tolpuddle Martyrs were George Loveless (1797–1874), James Loveless (1798–1873), Thomas Stanfield (1790–1864), John Stanfield (1812–98), James Brine (1813–1902) and James Hammett (1811–92). These men worked long hours as farm labourers for starvation wages, as was the norm in the 1830s, and were put in the dock when they had the temerity to ask for a pay rise.

Under the leadership of George Loveless, a Methodist preacher, they formed a Friendly Society of Agricultural Labourers, which was in effect the first trade union. This in itself was not against the law, but their undoing was that they made oaths of loyalty to each other, which according to an obscure law intended to prevent mutinies at sea, was unlawful. In 1834 they were given draconian sentences of seven years' hard labour in the penal colonies of Australia.

The injustice resulted in a groundswell of public anger and protests, resulting in various social reformers and Members of Parliament taking up their case. Eventually, in 1836, they were given full pardons. However, even then it took a while for news to reach the convicts, and it took some time before they made it back to England. James Hammett didn't get back until 1839.

They subsequently emigrated to Canada where they prospered. The exception was James Hammett, who remained in England and died in poverty in a Dorchester workhouse in 1891, aged seventy-nine. He is buried in Tolpuddle.

The legacy of the Tolpuddle Martyrs is the trade union movement, and an annual festival is held in Tolpuddle every July in recognition. The image shows the sycamore tree under which the six farm labourers met in 1833 to defend their right to a living wage. (© Historic England Archive)

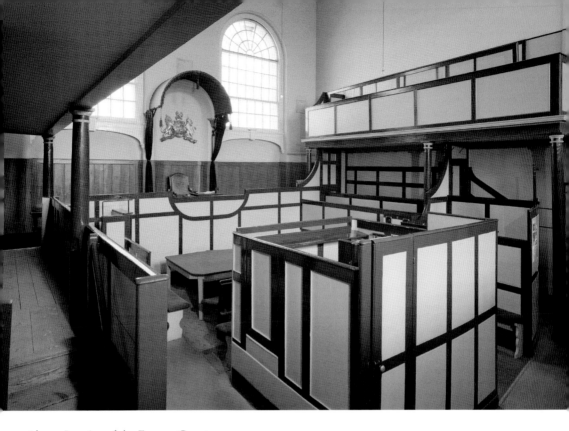

Above: Interior of the Former Court
This was the courtroom where the trial took place at Shire Hall, Dorchester. (© Historic England Archive)

Below: Martyrs' Cottages
This image shows the Martyrs' Cottages with the former Methodist chapel in the background. (© Historic England Archive)

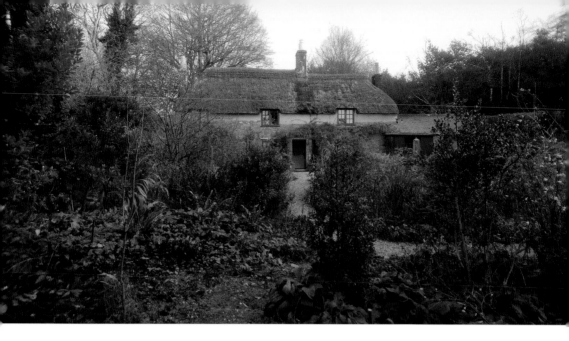

Above and below: Thomas Hardy

Thomas Hardy (1840–1928), the poet and novelist, was born in the above cottage on 2 June 1840. The thatched cottage at Bockhampton, near Dorchester, was built in 1801 by his great-grandfather, a stonemason.

The county provided the backdrop to his novels, which feature many aspects of Dorset life in the nineteenth century, and it is said that much of his inspiration was drawn from playing in the countryside surrounding the cottage as a child.

Hardy lived here until he was thirty-four, and returned to write some of his early novels, including *Under the Greenwood Tree* and *Far from the Madding Crowd*.

Towards the end of his life, from 1885 until his death, Hardy lived at Max Gate in Dorchester (see below), which he designed himself. Although Thomas Hardy is buried at Westminster Abbey, as befits his status, his heart is buried in his beloved native Dorset at Stinsford Church, not far from where he was born. (Author's collection)

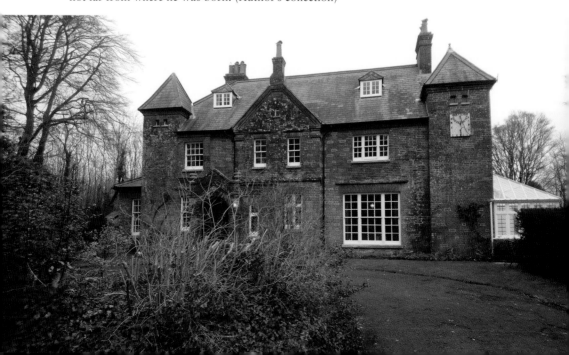

Right: Statue of Hardy,
Top O' Town
This statue of Hardy is a
Grade II listed structure and was
sculpted by Eric Kennington. It
was unveiled in 1931 by James
Matthew Barrie, who was the
author of *Peter Pan* and a friend
of Hardy's. The statue is a
recognition of the esteem Hardy is
held in Dorchester and the impact
he had on Dorset. (Author's
collection)

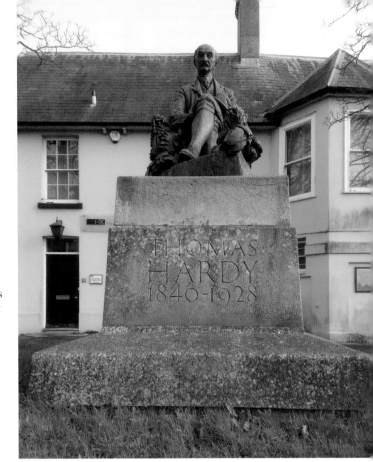

Below: Upwey Mill
Thomas Hardy used Upwey
Mill, which was built as a corn
mill in 1802, as the inspiration
for Overcombe Mill in his novel
The Trumpet-Major. (Historic
England Archive)

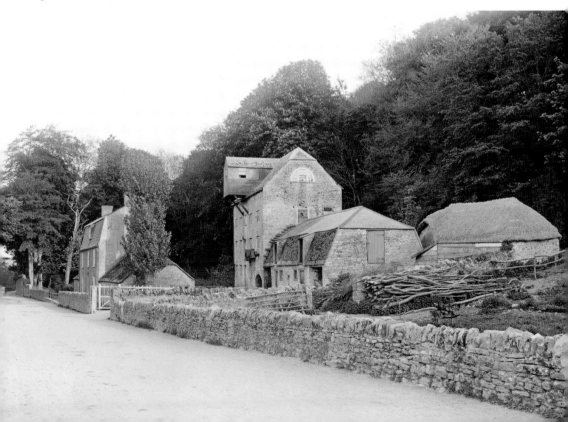

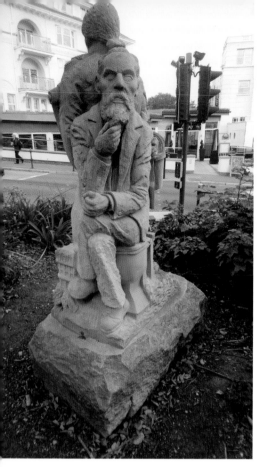

Christopher Creeke
Bournemouth architect and surveyor Christopher Creeke (1820–86) may not be a household name, but he certainly deserves to be, as he was instrumental in bringing improved sanitation to towns and cities.

In Bournemouth he is not forgotten, as there is a statue in his honour outside the Bournemouth International Centre, which features him irreverently sitting on the toilet. The same statue also features another of Bournemouth's famous sons: Captain Lewis Tregonwell (see Armed Conflict, p. 52).

Christopher Creeke must be famous, as he achieved the ultimate accolade of having a Bournemouth pub named after him. (Author's collection)

Mary Shelley
St Peter's Church, Bournemouth, is the burial place of Mary Shelley (1797–1851) and the heart of her husband, Percy Bysshe Shelley. Mary Shelley's claim to fame is that she wrote the novel *Frankenstein*, and as a result she, like Christopher Creeke, has been honoured by having a Bournemouth pub named after her. (Historic England Archive)

Right: Monument to Mary Shelley
There is also a monument to
Percy Bysshe Shelley and his wife,
Mary Shelley, at the west end of
Christchurch Priory. (Historic
England Archive)

Below: Mary Anning
Mary Anning (1799–1847) is buried
in this churchyard of St Michael the
Archangel, Lyme Regis, and a stained-
glass window was also constructed in
her memory.

 She was born into poverty in Lyme
Regis and helped to supplement the
family's meagre income by collecting
fossils and selling them as curios.

 She had little formal education
but became the world's foremost
authority on fossils. Her discoveries
encompassed some of the most
significant geological finds, providing
an insight into the earth's history and
the existence of dinosaurs.

 As Charles Dickens wrote,
'This carpenter's daughter has won a
name for herself and has deserved to
win it.' (Historic England Archive)

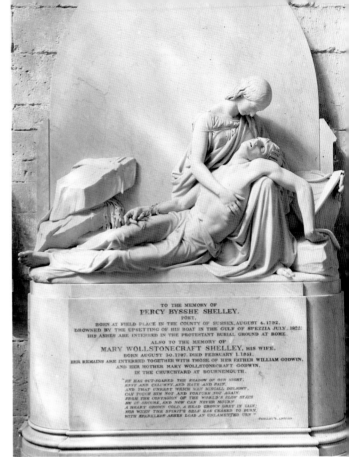

TO THE MEMORY OF
PERCY BYSSHE SHELLEY,
POET,
BORN AT FIELD PLACE IN THE COUNTY OF SUSSEX, AUGUST 4, 1792,
DROWNED BY THE UPSETTING OF HIS BOAT IN THE GULF OF SPEZZIA JULY, 1822:
HIS ASHES ARE INTERRED IN THE PROTESTANT BURIAL GROUND AT ROME.
ALSO TO THE MEMORY OF
MARY WOLLSTONECRAFT SHELLEY, HIS WIFE,
BORN AUGUST 30, 1797, DIED FEBRUARY 1, 1851.
HER REMAINS ARE INTERRED TOGETHER WITH THOSE OF HER FATHER WILLIAM GODWIN,
AND HER MOTHER MARY WOLLSTONECRAFT GODWIN,
IN THE CHURCHYARD AT BOURNEMOUTH.

*HE HAS OUT-SOARED THE SHADOW OF OUR NIGHT;
ENVY AND CALUMNY, AND HATE AND PAIN,
AND THAT UNREST WHICH MEN MISCALL DELIGHT,
CAN TOUCH HIM NOT AND TORTURE NOT AGAIN.
FROM THE CONTAGION OF THE WORLD'S SLOW STAIN
HE IS SECURE, AND NOW CAN NEVER MOURN
A HEART GROWN COLD, A HEAD GROWN GREY IN VAIN;
NOR WHEN THE SPIRIT'S SELF HAS CEASED TO BURN,
WITH SPARKLESS ASHES LOAD AN UNLAMENTED URN*
SHELLEY'S ADONAIS

St. Michael's Church, Lyme Regis

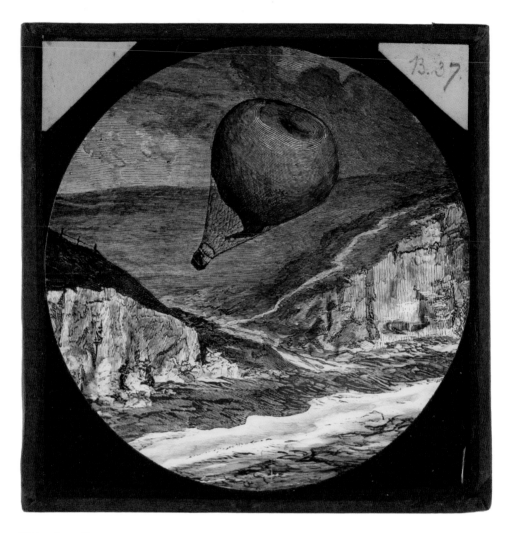

Walter Powell

Walter Powell was the Conservative MP for Malmesbury in Wiltshire from 1868 until his death in 1881. He had a keen interest in ballooning, and was invited by one of the premier balloon pilots of the day, Captain Templer, to come up in a newly developed military balloon called *Saladin*. Also invited was a Mr A. Agg-Gardner.

The ascent was near Bath, and the intention was to measure the temperature and atmospheric conditions on behalf of the Meteorological Society. However, after take-off, the balloon was immediately carried away at great speed by the wind over Somerset to Exeter and then into Dorset.

The crew managed to descend but hit the ground at such great speed that Templer was thrown out. The balloon bounced and rose again, causing Agg-Gardner to also be thrown out from a height of around 8 feet and break his leg.

Walter Powell was still aboard and was last seen flying over cliffs near Bridport. Neither he nor the balloon was ever seen again. (Historic England Archive)

Baden-Powell

Baden-Powell (1857–1941) learnt his scouting/tracking skills while serving in the army by observing tribesmen from around the world.

In 1899, he was posted to the Boer War in South Africa and was based in the town of Mafeking, which was under siege from the Boers. The British were outnumbered nine to one, and he had to use all his skills and resourcefulness to ensure that the town held out until it was relieved. One of the measures he took was to issue small boys with bicycles, so they could act as messengers. He came to value their efficiency and cheerfulness.

In 1904, Baden-Powell attended the twenty-first celebrations of the Boys Brigade and was asked to devise a scheme for giving greater variety in their training. The programme he devised was called Scouting for Boys, which the Boys Brigade only partially adopted. However, realising he was on to something he contacted a friend who owned Brownsea Island in Poole Harbour, Charles Van Raalte, and initiated the first scout camp.

This bronze statue of Baden-Powell is situated on Poole Quay. (Author's collection)

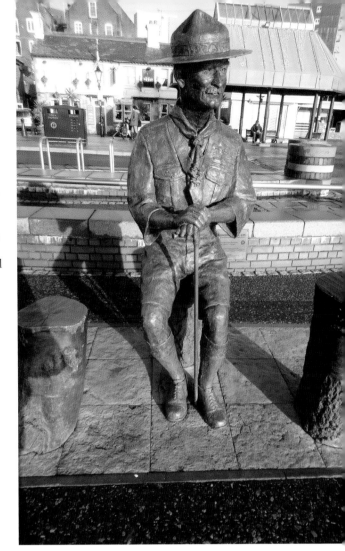

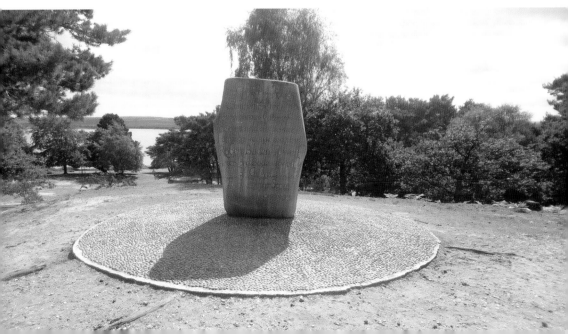

Previous page below: Scout Stone
Baden Powell wanted to discover what kind of boy would be interested in his scheme, so he invited pupils from public schools and those from working-class families, and also included both city and country dwellers. Twenty-one boys, including three from Poole and seven from Bournemouth, were at Brownsea on 31 July 1907. They were divided into four patrols and spent their days learning and practising the skills of scouting, campcraft, cooking, observation, woodcraft, life-saving, hiking, stalking, boating, etc., before retiring for campfires in the evening. The camp was a great success and was the catalyst for the scouting movement, which then, as today, had appeal to those of all backgrounds.

A stone on the island at the site of the first campsite commemorates the event, and 50 acres are set aside for use by the scouts for camping and scout-related activities. Today, there are 16 million scouts in 150 countries.

The Girl Guides were formed in 1910 by Baden-Powell's sister, Agnes Baden-Powell, who also took the Guides to Brownsea for their first camp.

Below: Guglielmo Marconi
Guglielmo Marconi (1874–1937) broadcasted the first ever radio signals from the Haven Hotel in Sandbanks, Poole, to the Isle of Wight in 1896, using a 120-foot mast. Many aspects of our lives today, including radio, television, satellite links and mobile phones, owe their development to this broadcast.

The success of this experiment allowed Marconi to subsequently transmit the first radio message across the Atlantic from Angrouse Cliffs, just south of Poldhu Cove near Mullion in Cornwall, in which three dots (S in Morse code) were received by Marconi in Newfoundland on 12 December 1901. (© Historic England Archive. Aerofilms Collection)

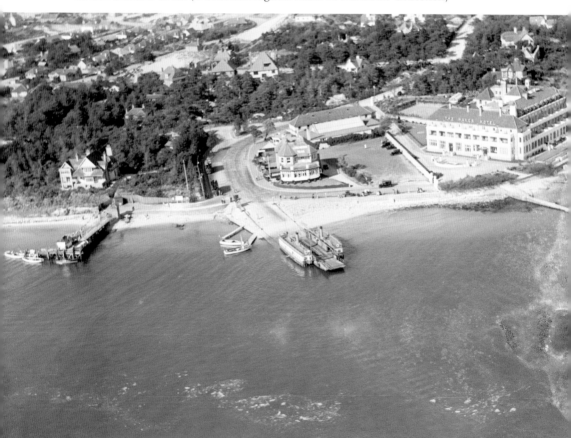

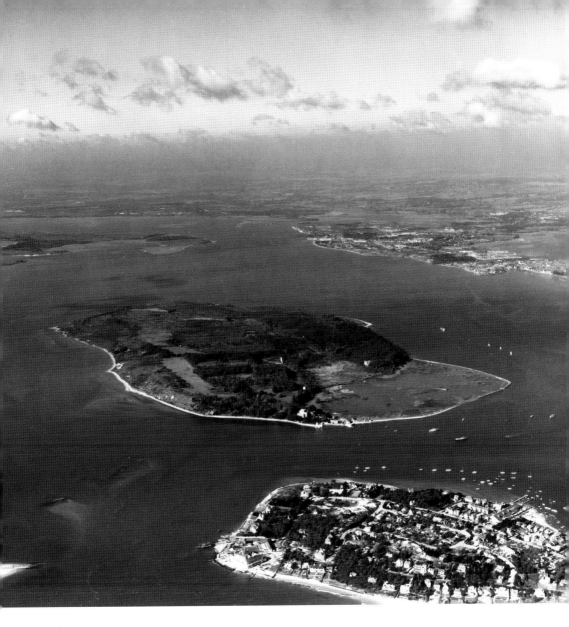

Enid Blyton

Enid Blyton (1897–1968) regularly holidayed in Dorset and became immersed in life in the Purbecks. At one time she owned Stourton Manor Farm Chapel, Stourton Caundle, which was originally a medieval chapel and was said to be the inspiration for her book *Five Go to Finniston Farm*.

The Famous Five novels are synonymous with the Purbecks, and many local landmarks were used for the basis of the stories; for instance, Kirrin Castle, which features in *Five on a Treasure Island*, is in fact Corfe Castle, and *Five Go to Mystery Moor* was based on Stoborough Heath near the Blue Pool.

Keep Away Island, which features in *Five Have a Mystery to Solve*, is Brownsea Island at the time when it was owned by the reclusive Mary Bonham-Christie, who would not allow visitors to the island. The image shows Brownsea Island in Poole Harbour and the tip of the Sandbanks Peninsula. (© Historic England Archive. Aerofilms Collection)

Armed Conflict

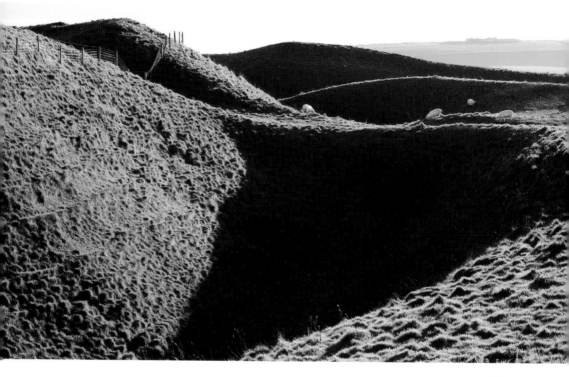

Above and below: Maiden Castle

The earliest conflict in Dorset is considered to be the defence of Maiden Castle in the first century AD by the Celts against the Romans. Archaeological evidence suggests that the Celtic Dorset Durotriges tribe were overwhelmed by the superior might and discipline of the Roman army. One of the many finds at the site was this human vertebra with an iron spearhead thrust through it.

The first image shows a causeway over the ramparts at the west entrance, whereas the second image shows a view looking over the ramparts to the new town of Poundbury, which was designed by Prince Charles. (© Historic England Archive)

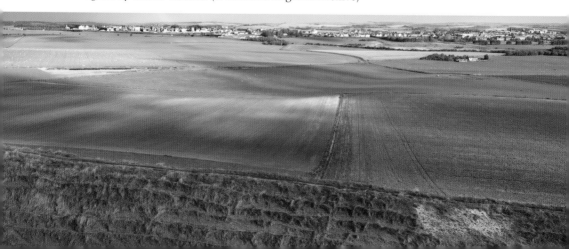

Above: Wareham Walls

The town walls of Wareham were built in AD 876 at the behest of King Alfred the Great to defend against the frequent raids made by the Danes coming inland from the River Frome. They are regarded as the best-preserved Saxon town defences in England. This aerial image shows the now earthen walls on the left of the picture. (© Historic England Archive. Aerofilms Collection)

Right: King Alfred's Memorial, Swanage

King Alfred's Wessex was the only kingdom in England to hold out against the Danes, whose frequent raids were a constant thorn in the side. In AD 875, King Alfred brokered a peace deal with them, which they reneged on two years later. However, by then, King Alfred had developed a new strategy that involved thwarting the Danes at sea, before they could set foot on English soil. In preparation for this, he had overseen the construction of numerous longships, in what was the advent of the Royal Navy.

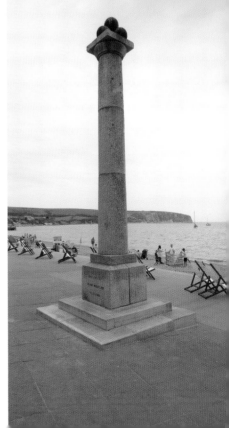

The strategy was put to the test when a fleet of Viking longships were spotted off Peveril Point near Swanage. Alfred's ships sank all 120 of them, although some historians say they were aided and abetted by a storm.

The cannonballs on top of the monument are of no significance to this battle, but were fired at British ships by the Russians during the Crimean War. (Author's collection)

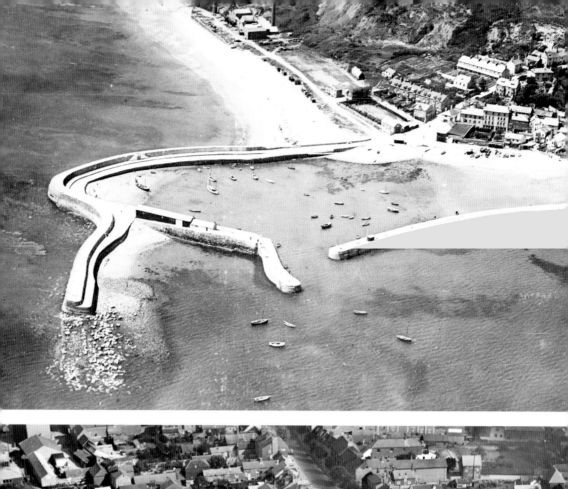
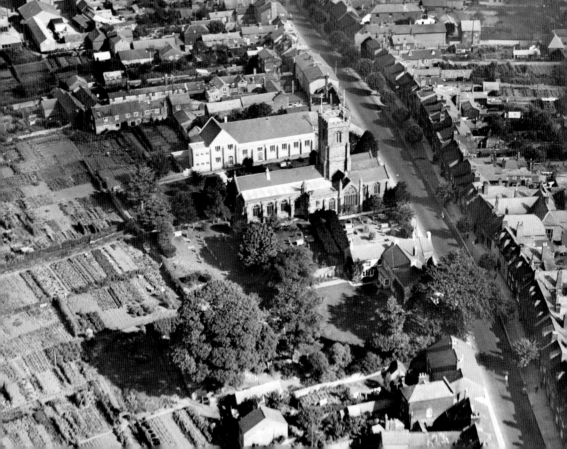

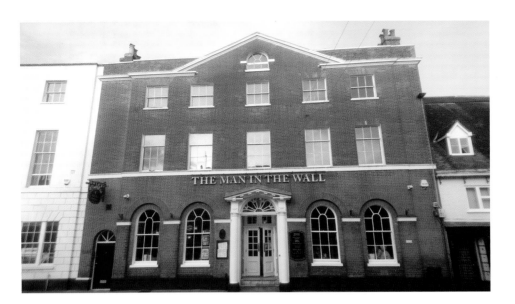

Opposite above: The Monmouth Rebellion

The Duke of Monmouth and his rebel army arrived from Holland, where he had been in exile, on 11 June 1685 on a shingle beach to the west of Lyme Regis Cobb, now called Monmouth Beach.

Upon landing, Monmouth raised his standard, which consisted of a green banner with the words 'Fear nothing but God' emblazoned on it in gold. He announced that he had come to defend the Protestantism and to deliver the country from Catholicism and the tyranny of James II. He also promised freedom of worship to Nonconformists and Anglican Protestants alike. The entire party then sank to their knees in prayer. (© Historic England Archive. Aerofilms Collection)

Opposite below: The First Casualty of the Monmouth Rebellion

When Monmouth and his followers first landed in England at Lyme Regis, the Royalist army was still mustering in London, as troops were recalled from Ireland and Holland. The rebels took full advantage and visited Bridport on a recruitment drive on 14 June 1685, where they registered their first victory in a skirmish against the Dorset militia. They also received a timely boost, as many from Bridport (including most of the local militia) and other nearby towns – particularly the town of Colyton, East Devon – responded to the call.

A brass memorial plaque in the south chapel of St Mary's Church, Bridport, commemorates the first casualty of the Monmouth Rebellion: Edward Coker, who was shot at the Bull Inn, Bridport, by an officer of Monmouth's rebels by the name of Venner. This image shows St Mary's Church, Bridport, from the air. (© Historic England Archive. Aerofilms Collection)

Above: The Man in the Wall

After the rout of the Duke of Monmouth's rebel army at Sedgemoor in 1685, Monmouth fled across Dorset and was captured on Horton Heath. He was then taken to be identified by the nearest magistrate, who was Anthony Ettrick of Holt Lodge, who was the recorder of the borough of Poole. Ettrick ordered him to be taken to the Tower of London, where he faced execution.

Ettrick went on to achieve a degree of posthumous fame as Wimborne's 'Man in the Wall'. He felt slighted by the people of Wimborne, and stated 'that I will never be buried within or without the walls of Wimborne Minster'. However, he later relented and wanted to be buried with his ancestors, but still wanted to keep his vow, so obtained permission to be buried in the wall of the minster upon his death, which he confidently predicted would be in 1693. His actual death was not until 1703, so a bodged attempt was made to change the inscription on the side of the coffin.

There is a Wetherspoon's pub in Wimborne named the 'Man in the Wall' in his honour. (Author's collection)

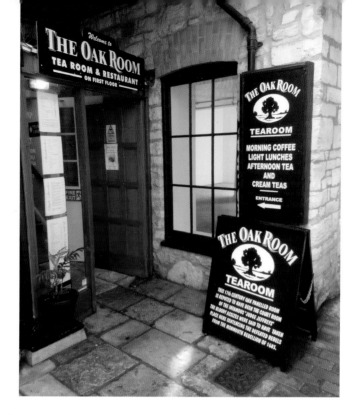

The Bloody Assizes

The old Dorchester Assize Court became the Antelope Hotel, but is now a passageway containing retail outlets called Antelope Walk. On 6 September 1685, Judge Jeffreys ordered the Oak Room of the Dorchester Assize Court to be adorned with red. This was to provide a grim reminder of what lay in store for the prisoners of Monmouth's rebel army captured after the Battle of Sedgemoor. The painful kidney stone he was suffering from at the time didn't help his mood.

Jeffreys stated, as he also did at other trials, 'that if any pleaded not guilty, and were subsequently found to be guilty, they would not have long to live; and that, if any expected favour they should plead guilty'. Many prisoners had seen enough of him to not trust him to honour his word, or show any leniency, and indeed those that did plead guilty expecting mercy received none.

The executioners at Dorchester were struggling, as many prisoners were convicted of high treason, the sentence for which was to be hanged, drawn and quartered. They complained that they could only cope with thirteen of these a day, as the process was pretty time-consuming. As a result, gallows were also erected at Bridport, Weymouth, Poole and Wareham, as the condemned were farmed out in batches to the various locations. Twelve of the miscreants were hanged on Monmouth Beach, Lyme Regis, at the site of the original invasion.

Those who were not executed were sentenced to transportation. Others were sentenced to receive public floggings. Lord Grey, the officer in charge of the rebel cavalry, was sentenced to be whipped through Dorchester on market day, and then to receive the same punishment on market day in Shaftesbury.

In many instances, those of higher social status received less severe punishment. In the case of Lord Grey, his wealth was in life estate, which meant if he died, his land went to his heir, whereas if he were pardoned he would be able to pay a large ransom. Jeffreys extorted £40,000 from him in return for a more lenient sentence.

The Oak Room is now a café of the same name, within Antelope Walk, which still maintains the original oak paneling. (Author's collection)

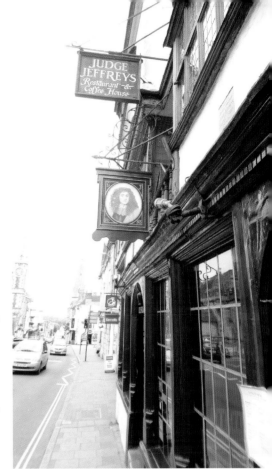

Right: Judge Jeffreys' Lodgings
The rooms where Judge Jeffreys lodged at No. 6 High West Street, Dorchester, during the Bloody Assizes are now the Judge Jeffreys Restaurant and Coffee House. (Author's collection)

Below: St Peter's Church, Dorchester
St Peter's Church, which is opposite Judge Jeffreys' Restaurant and Coffee House, was built around 1420. During the Bloody Assizes, many severed heads were placed on spikes to cower the local population. The church also features in several of Thomas Hardy's novels. (Historic England Archive)

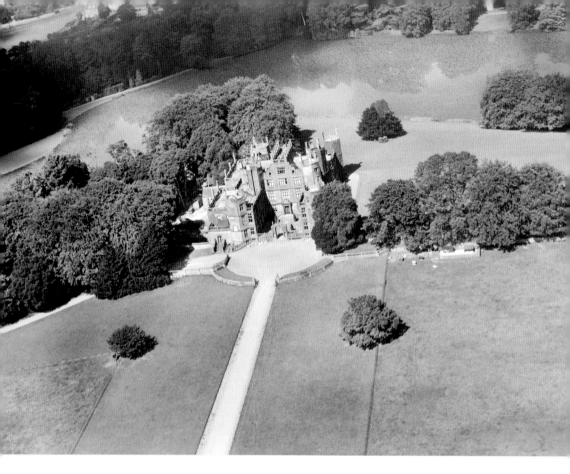

King William of Orange Makes a Proclamation in Dorset

The brutality, severity and unfairness of the retribution given by Judge Jeffreys at the Bloody Assizes shocked and antagonised the whole of the country. This combined with various moves by King James II to turn the nation into a kind of Catholic military dictatorship were beginning to cause widespread alarm.

Monmouth was seen as a noble martyr for the Protestant cause, and James's Protestant opponents planned once more to remove the king. A meeting took place at Charborough House near Sturminster Marshall in Dorset in 1686. It was hosted by Thomas Erle Drax, who was the MP for Wareham and Deputy Lieutenant of Dorset. As a result of the meeting, seven leading statesmen and Protestant campaigners, including the Bishop of London, approached Mary, James II's Protestant daughter, to see if she was willing to take the throne in the event of her father being forced to abdicate.

She agreed on the condition that her husband and cousin, William, would rule alongside her as a joint monarch. This was considered to be a suitable option, as William of Orange was the Stadtholder of Holland and the grandson of Charles I.

William and Mary were subsequently invited to come to England from Holland, and this was termed the Glorious Revolution – a kind of coup d'état.

William landed at Brixham, Torbay, Devon, on 5 November 1688 with an army of Dutch and English soldiers. William's army then advanced to Sherborne Castle in Dorset, where he issued a proclamation, insisting that he came as a liberator not a conqueror. He was anxious that the coup would be popular and bloodless.

The image shows Sherborne Castle from the air. (© Historic England Archive. Aerofilms Collection)

Peter Jolliffe

At the height of Poole's prosperity during the Newfoundland trading years, this house was owned by one of the town's most prominent merchants: Peter Jolliffe.

In 1694, Peter Jolliffe came to the rescue of a fishing boat off the coast of Weymouth that was being attacked by a French privateer. He managed to force the privateer aground near Lulworth, where the crew were taken prisoner. His heroic deed came to the attention of King William III, who rewarded him with a large bounty, which enabled him to buy the house.

His great-grandson, also Peter Jolliffe, was responsible for the rebuilding of St James's Church in Poole, and was rector of Poole for seventy years between 1791 and 1861.

Rachel Allenby, a descendant of Peter Jolliffe and a Poole developer and entrepreneur, purchased the house in 1968, as well as Newfoundland House on Poole Quay, which celebrated Poole's trade with Newfoundland in the eighteenth century. (Author's collection)

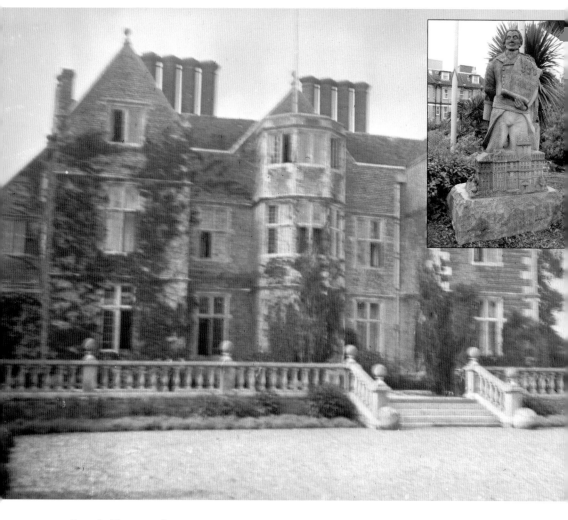

Captain Tregonwell

This image depicts Anderson Manor, Anderson, where Tregonwell lived before arriving in Bournemouth.

A statue of Captain Lewis Dymoke Grosvenor Tregonwell (1758–1832) was made by Jonathon Sells, the Corfe Castle-based stonemason, and backs onto that of Chistopher Creeke (see Historical Figures and Events).

In his left hand, Tregonwell holds a scroll that has the names of Bournemouth's three VC winners. They are Corporal C. R. Noble, Sergeant F. C. Riggs and Lieutenant-Colonel D. A. Seagrim. In his right hand he holds a bucket and spade.

Tregonwell is regarded as the founder of Bournemouth. He was a Dorset man from nearby Anderson, and first came to Bourne, as it was called then, while staying with his wife in Mudeford near Christchurch. He liked the place so much that he purchased some land, and then in 1810 had a house built, which precipitated the growth of Bournemouth. During his military career in the Dorset Yeomanry, he patrolled the Bournemouth and Poole coastline looking for smugglers. He is buried in St Peter's Church, Bournemouth (see Historical Figures and Events – Mary Shelley). (Historic England Archive; LordHarris CC BY-SA 3.0)

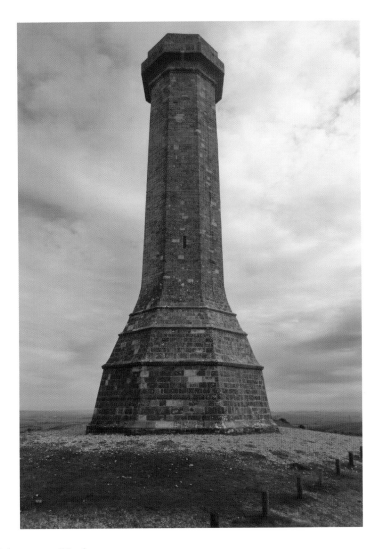

Thomas Masterman Hardy

In Dorset we are fortunate to have two famous Thomas Hardys, the other being Thomas Masterman Hardy (1769–1839), who was Lord Nelson's stalwart captain on HMS *Victory* on that fateful day of 21 October 1805, when the Royal Navy destroyed any French illusions of maritime superiority at the Battle of Trafalgar.

As Nelson lay dying below decks, having been hit by a French sniper, he asked Hardy the state of the battle raging on above him. Hardy replied with the truthful positive synopsis, and Nelson then said, 'Thank God I have done my duty.' He then famously said 'Kiss me Hardy.' Hardy duly obliged, kissing his dying friend on the forehead. A famous painting by Arthur Dervis, who was on board the *Victory* himself at the time, captures this historic scene.

The memorial to Rear Admiral Sir Thomas Masterman Hardy, as he later became, is situated on Blackdown Hill near Portesham, and was built from local Portland stone in 1844 to look like a naval spyglass. The foundation stone was laid by Hardy's daughter. The location is fitting as he was brought up in the village of Long Bredy, and then subsequently lived in Portesham. (Author's collection)

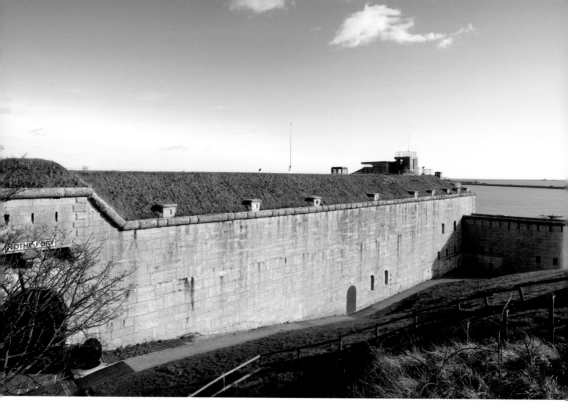

Above and below: Nothe Fort

Nothe Fort is a Grade I listed building located at the entrance of Weymouth Harbour. It was built between 1860 and 1872, after the Crimean War, for the purpose of defending Weymouth and Portland. At the time, and until 1995, Portland was an important Royal Navy base.

The fort was originally fitted with heavy muzzle-loaded cannons, but during the Second World War it was manned with QF 3.7-inch guns. (© Historic England Archive)

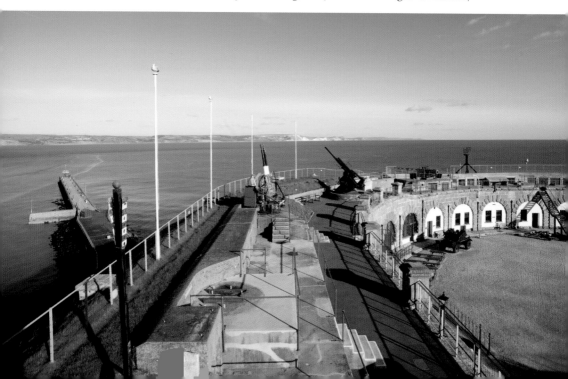

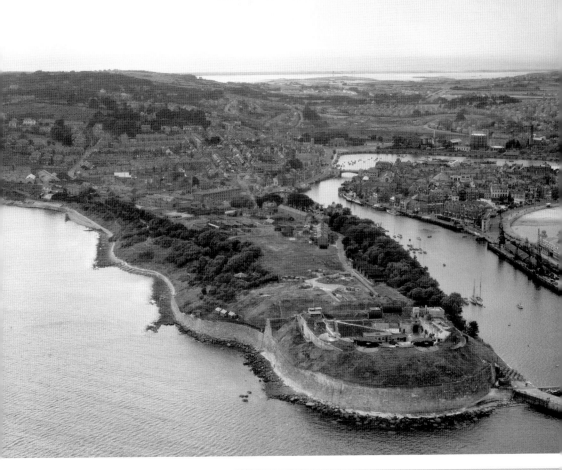

Above: Position of Nothe Fort
This image shows the position of the
fort on the peninsula. (© Historic
England Archive. Aerofilms Collection)

Right: Anzac Memorial, Weymouth
The Anzac War Memorial in
Weymouth, erected in 2005 close
to the Weymouth Cenotaph, is in
memory of Anzac volunteer troops
who, after action in Gallipoli in 1915,
passed through hospitals and training
camps in Dorset. (© Historic England
Archive)

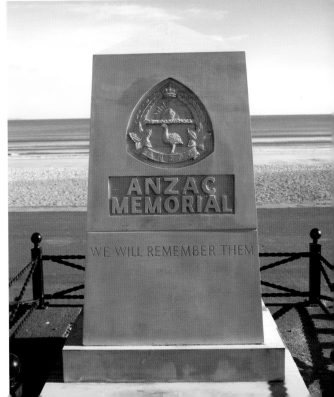

Lawrence of Arabia
St Martin's Church, Wareham, features a sculpture memorial by Eric Kennington, situated in the north aisle, of Thomas Edward Lawrence – aka Lawrence of Arabia (1888–1935). However, he is actually buried at his own parish church in Moreton.

From 1923, the champion of Arab independence during and after the First World War lived nearby at Bovington in an austere woodman's cottage called 'Clouds Hill'. It was while living here that he tried to escape his 'Lawrence of Arabia' fame by enrolling as a private in the army at nearby Bovington Camp.

He was killed in 1935, near his cottage at Clouds Hill, while riding his motorbike through Dorset's country lanes at breakneck speed. (Historic England Archive)

Old Lifeboat Station, Poole/Hero of Dunkirk
Situated on the far reaches of the Eastern Quay at Poole next to Fisherman's Dock is the Old Lifeboat Station, which was built in 1882 and is now a museum. It houses a hero of Dunkirk, *Thomas Kirk Wright*.

Thomas Kirk Wright was built in 1938 and is now one of only two surviving surf-class lifeboats. She was Poole's first motorised lifeboat. On the first day of the evacuation she was the first lifeboat to make it across. She made three trips over four days, rescuing many troops. On the final return journey, she was loaded with French troops and came under heavy fire, which caused widespread damage to the boat. Although no one was hit, she had to limp home on only one engine.

After extensive repairs she returned to lifeboat duty in Poole before retiring in 1962. (Author's collection)

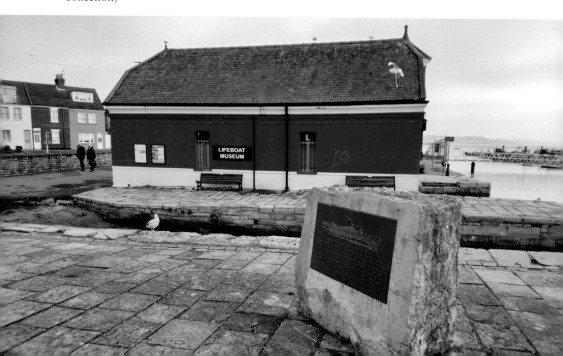

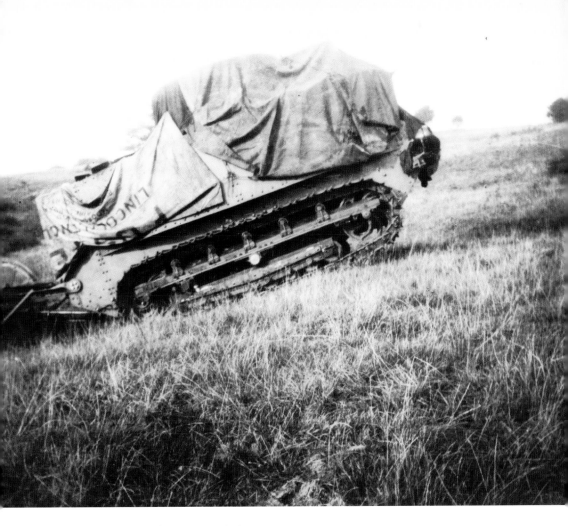

Tyneham/Army Ranges and Bovington Tank Museum

In 1943, during the build up to D-Day, the people of Tyneham near Lulworth were told that the army needed their village to prepare for the forthcoming assault on German-occupied France. They were given three weeks to pack their bags and leave. They were told they would be able to return at a future date, but that date never came, as the army continued to use the area for training.

One former inhabitant, Arthur Grant, did return to the village in which he grew up, but only to be buried in the village church, as was his dying wish. Relatives poignantly found his name on a coat peg in the village school he attended.

The village is left how it was for posterity, and the public can visit when the army ranges are open. It is an interesting place to visit as it is a kind of 1940s time warp. The military firing ranges in the Tyneham and Lulworth area cover an area of approximately 2,830 hectares, and are owned by the Ministry of Defence and are part of the Armoured Fighting Vehicles Gunnery School based at Lulworth.

At nearby Bovington there is a tank museum where exhibits can be seen such as the tank shown in this photograph of 'Little Willie'. This particular model is a second prototype of the tank built in 1915, which led to the development of the British Mark 1 tank. Little Willie holds the distinction of being the oldest surviving tank. (© Historic England Archive)

D-Day Memorial, Weymouth
American troops were a massing in vast numbers in Dorset from 1943 onwards in preparation for the D-Day landings, in which Weymouth, Portland and Poole were major embarkation points. There is a memorial on Weymouth Esplanade in recognition of this, which features a photograph of American Rangers marching along the Esplanade prior to D-Day. More than 2,000 were killed or wounded on Omaha Beach, spearheading the invasion of Normandy, as they fought to secure the beachhead and the strategic Pointe du Hoc.

There is also a United States D-Day memorial on nearby Portland at Victoria Gardens, as a combined total of more than 500,000 troops and 145,000 vehicles left from both harbours. (Author's collection)

D-Day Plaque, Custom House, Poole
Poole was also a major embarkation point for allied troops during Operation Overlord. The vast majority of the troops were American and were destined for Omaha and Utah landing beaches in Normandy.

Poole shipyards built many of the landing craft, gunboats and launches. J. Bolson & Son of Hamworthy really stepped up to the plate in the hour of need by transforming their small yacht-building outfit into an operation that was manufacturing a landing craft per day.

Dorset Yacht Company of Hamworthy were also engaged in building landing craft, while other Poole/Hamworthy firms based around the Quay, such as Sydenhams, Newmans, and Burt and Vick, were involved in the manufacture of Mulberry Harbour, which was the temporary harbour transported across the Channel to serve as a makeshift base from which to launch the assault.

Hamworthy was a training base for troops preparing for D-Day, and had a major role in Operation Smash, a rehearsal for the real thing. This involved assaulting beaches at Studland and Shell Bay, both considered very similar to those in Normandy.

On 5 June 1944, the vanguard of 3,000 assault troops left from Poole Quay. They were followed in subsequent weeks by a total of 22,000 soldiers and 3,500 vessels. (Author's collection)

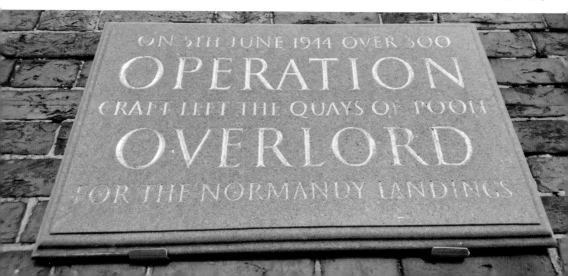

ON 5TH JUNE 1944 OVER 300
OPERATION
CRAFT LEFT THE QUAYS OF POOLE
OVERLORD
FOR THE NORMANDY LANDINGS

Weymouth Cenotaph
A short distance away from the D-Day memorial on Weymouth Esplanade is a cenotaph to those that died in both world wars. (© Historic England Archive)

Castles

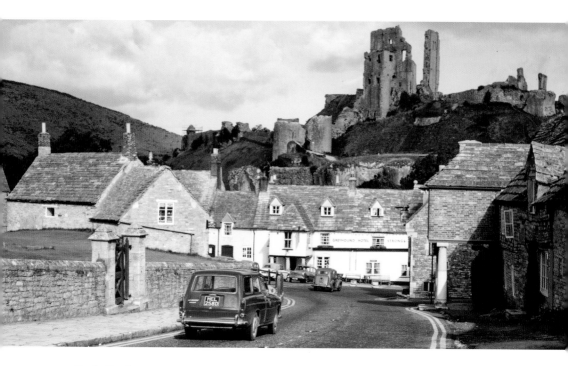

Corfe Castle

After King Alfred had defeated the Danes off the coast of Peveril Point near Swanage, he built a castle at Corfe in order to protect the area from further Viking marauders. The castle's gruesome early history involved the murder of a Saxon king (see Saints, Martyrs, Abbeys, Priories, Monastic Churches and Others). Then in the eleventh century, William the Conqueror turned the castle into an impregnable Norman fortress of Purbeck limestone. The keep was built later in the early twelfth century for Henry I, William the Conqueror's son.

Shortly after Henry's death, the castle was involved in a significant siege during the Anarchy, which was a civil war between the armies of Stephen, who had assumed the role of king (r. 1135–54) and was the son of William the Conqueror's daughter, and Matilda, the daughter of Henry I. Both were fighting for the crown. Empress Matilda resided at Corfe Castle, which proved impregnable to Stephen's forces.

King John (r. 1199–1216) stayed frequently at Corfe and made use of the dungeon facilities to starve his enemies to death. He murdered his nephew Arthur, who also had a claim to the throne. He also forced Arthur's sister to live under house arrest at the castle before she was imprisoned in Bristol for forty years.

Corfe was a royal castle until Queen Elizabeth I sold it to one of her favourites, Christopher Hatton, who in turn sold it to John Bankes.

During the Civil War, Lady Bankes held the castle against two separate sieges (see Pubs and Hotels), before the Parliamentarians finally captured it in 1646, after she was betrayed by one of her own soldiers.

After a period of confiscation, the castle was returned to the Bankes family, who retained it within the family until 1982, when they bequeathed it to the National Trust. (© Historic England Archive)

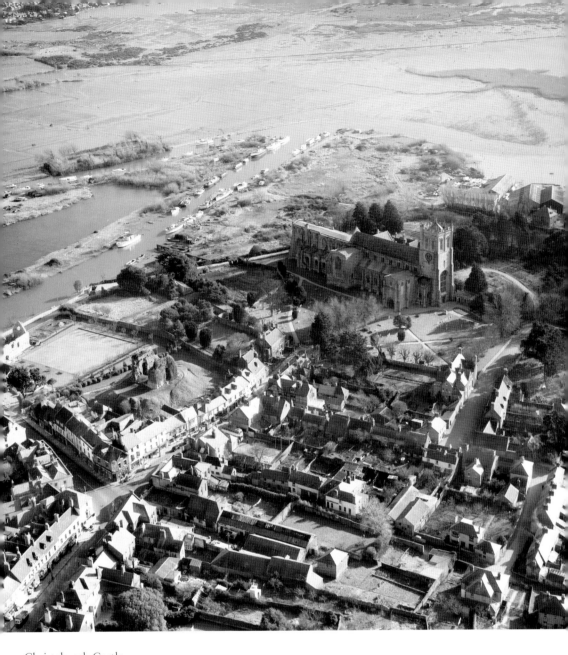

Christchurch Castle

The castle's strategic position controlled Christchurch Harbour and routes inland via the Stour and the Avon. It is believed to stand on a site of an earlier wooden structure erected by King Aethelwold of Wessex in the tenth century to guard against Viking invasions. It was subsequently strengthened with the addition of a motte by King Edward the Elder.

The keep, which survives today, was built by the Normans, whose greater concern was to subjugate the local populace. It is situated near another fine example of Norman architecture, known as the Norman House or Constable's House, which, like the castle, dates back to the twelfth century.

Like Corfe Castle, Christchurch Castle was involved in the Anarchy (1135–53) involving Stephen and Matilda, and also the civil war involving the Roundheads and Cavaliers (1642–51).

This image shows the castle and nearby priory from the air. (© Historic England Archive. Aerofilms Collection)

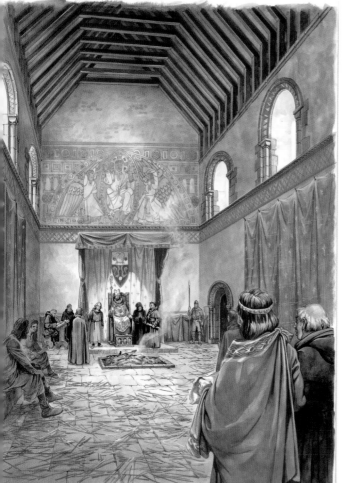

Above: The keep and motte of Christchurch Castle. (© Historic England Archive)

Left: Sherborne Old Castle Sherborne Castle was originally built for Roger de Caen, Bishop of Salisbury, in the twelfth century. This image is a reconstruction illustration depicting the interior of the Great Hall, as it may have appeared then, and shows Roger de Caen, sitting below a painting of Christ in majesty. (© Historic England Archive)

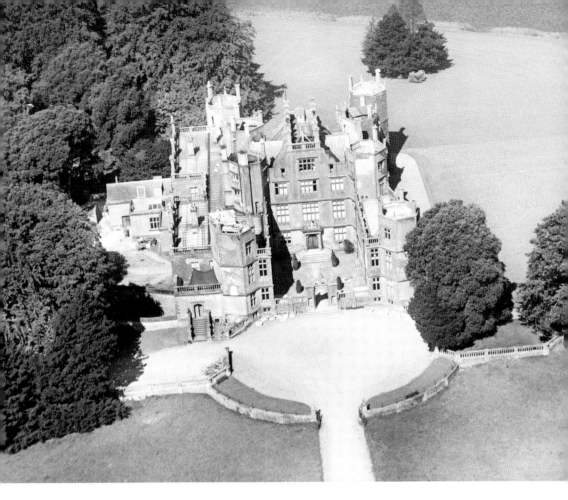

Sherborne Castle

Many years later, Sir Walter Raleigh had designs on the castle. He was a court favourite of Queen Elizabeth I and encouraged her to think he was a suitor by giving her an expensive ring, but neglecting to inform her that he had secretly married one of her ladies-in-waiting. When the queen found out she sent them both to be imprisoned in the Tower of London. They were released after five weeks, but in the meantime Raleigh realised that he would be unable to afford the castle, so instead bought a hunting lodge nearby.

This was seized by the Crown in 1617, shortly before Raleigh was beheaded in 1618. It was then sold by King James I to John Digby, 1st Earl of Bristol, whose descendants still own it today.

The former hunting lodge became the new Sherborne Castle, after the old castle was destroyed in 1645 by General Fairfax and his Parliamentarians during the Civil War. The new castle also played a part in the Glorious Revolution, when, as a result of a meeting at Charborough House, Dorset, William of Orange arrived by invitation in Brixham, Devon (see Armed Conflict) and then moved on to Sherborne Castle where he stayed as a guest, before issuing a proclamation of his intentions. (© Historic England Archive. Aerofilms Collection)

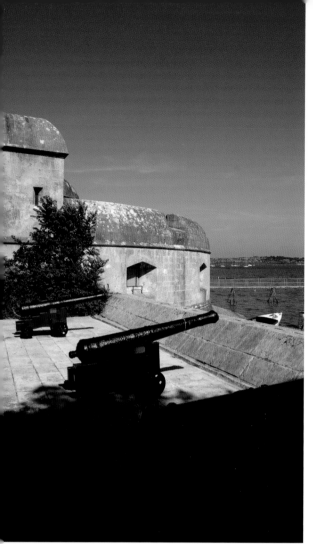

Portland Castle

Portland Castle is one of three castles on Portland, one of the others being Rufus Castle, which is also known as Bow and Arrow Castle and is situated at Church Ope Cove. It is the oldest of the three, and is now in ruins. The keep is believed to have been built in Norman times during the reign of King Rufus (William II). The other is Pensylvannia Castle, which was built in 1797 by John Penn, the grandson of William Penn, the founder of Pennsylvania.

Portland Castle was built in 1540, as part of a ring of steel constructed by Henry VIII to protect the coastline against potential invasion from Spain and France. Both countries were affronted by Henry VIII declaring himself the head of the English Church instead of the pope, which he did as a means to divorce his first wife, Catherine of Aragon, and marry Catherine's lady-in-waiting, Anne Boleyn. This period was known as the Reformation, as the official religion changed from Catholicism to Protestantism.

Defenders of the castle were never required to fire a shot in anger, as the invasion never came. This was also the case with the anticipated German Second World War invasion, for which the castle was also in a state of readiness. At one time Sir Walter Raleigh was governor of the castle.

The image shows the eastern outer gun battery. (© Historic England Archive)

An interior view of the window. (© Historic England Archive)

Above left: The dining hall. (© Historic England Archive)

Above right: A model of the castle's founder situated within. (© Historic England Archive)

Below: Sandsfoot Castle
Sandsfoot Castle is an artillery fort near Weymouth that was constructed as part of Henry VIII's coastal defences. It is the sister castle to Portland Castle. This image shows the castle gardens. (Historic England Archive)

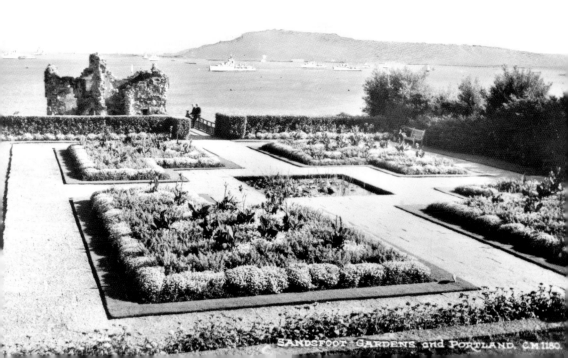

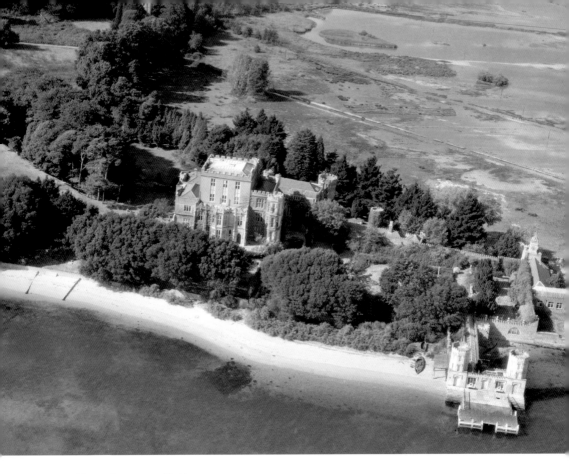

Above: Brownsea Castle

Brownsea Castle was also built by Henry VIII and was used to defend the strategic position of the Poole Harbour entrance at Brownsea Island. The castle that exists on the island today still retains some of the original stonework. (© Historic England Archive. Aerofilms Collection)

Below left and below right: Lulworth Castle and Chapel of St Mary

Lulworth Castle, which is contained within the privately owned Lulworth estate, was built in the early seventeenth century as a hunting lodge for Thomas Howard, who in turn sold it to Thomas Weld in 1641. Thomas Weld was Dorset's leading Catholic, so wasted no time in employing the Bastard brothers of Blandford (see Historical Figures and Events) to design the first free-standing Roman Catholic chapel to be built in England since the Reformation. The castle remains the property of the Welds to this day. (© Historic England Archive)

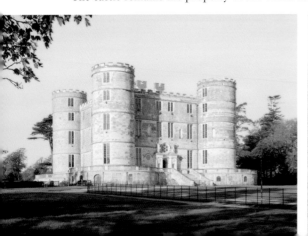 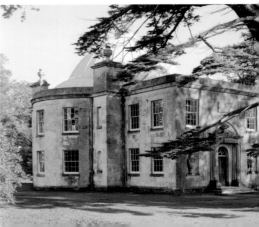

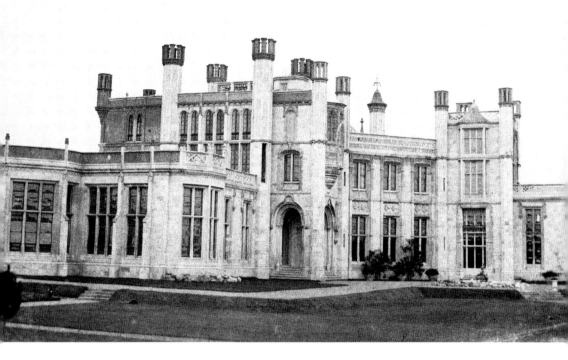

Above: Highcliffe Castle

Highcliffe Castle is a Grade I listed building built between 1830 and 1836 for Lord Stuart de Rothesay. It was a lavish residence visited by royalty and other nobility. In the 1950s and early 1960s, it was used as a children's convalescent home and then as a seminary for priests, before falling to rack and ruin after suffering two fires. It was purchased by Christchurch Borough Council in 1977, and is now open to the general public throughout the year. (Historic England Archive)

Overleaf above: Durlston Castle

Durlston Castle is situated within Durlston Country Park Estate on the Jurassic Coast near Swanage. It is a folly built by George Burt, one of the founding fathers of Swanage, from local stone (see Industry/Quarrying in the Purbecks). (© Historic England Archive. Aerofilms Collection)

Overleaf below: The Globe

The Globe, which is situated near Durlston Head within the grounds of Durlston Country Park, weighs in at 40 tons and has a diameter of 10 feet. It is one of the largest and heaviest spheres in the world, and was commissioned by George Burt. It is engraved with an 1880s map of the world, and also includes quotations from the Bible and Shakespeare. (© Historic England Archive)

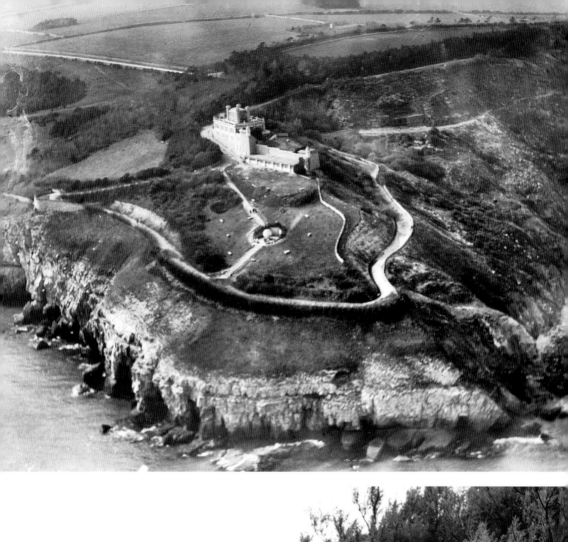

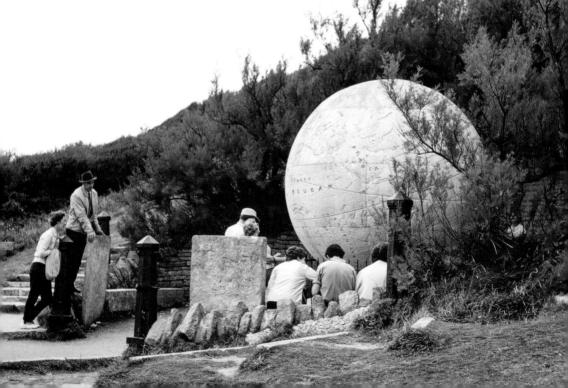

Industry Past and Present

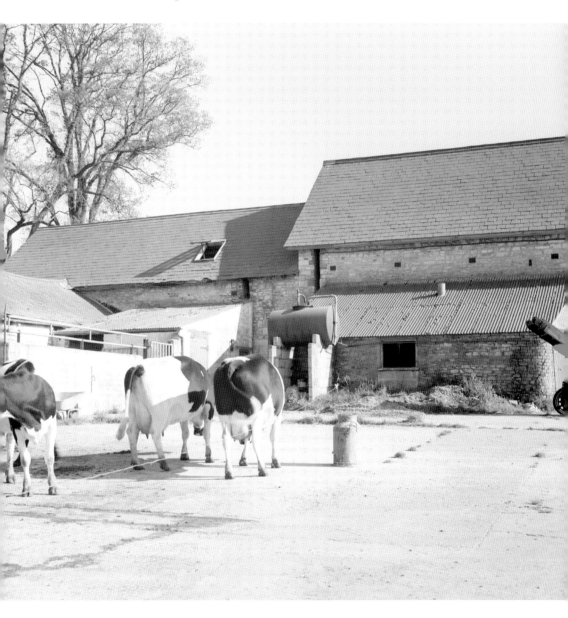

Above and overleaf: Agriculture

Agriculture has traditionally been the major industry in Dorset, and for centuries Dorset has been renowned for dairy farming, particularly in the lush meadows of the Blackmore Vale around Marnhull, where thousands of cows can still be seen munching their way through the fields in pastoral scenes not too dissimilar to that which Hardy's fictional milkmaid, Tess of the D'Urbervilles, would have witnessed. (© Historic England Archive; Historic England Archive)

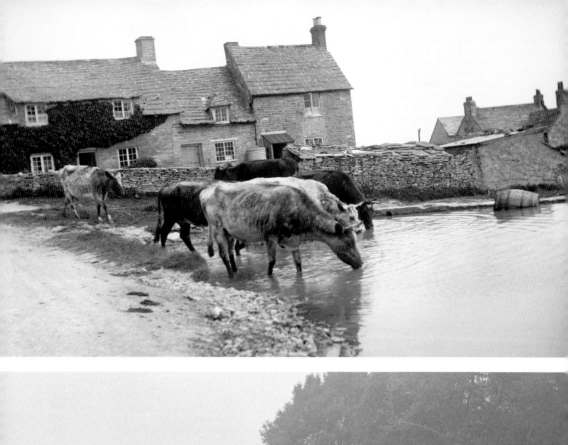
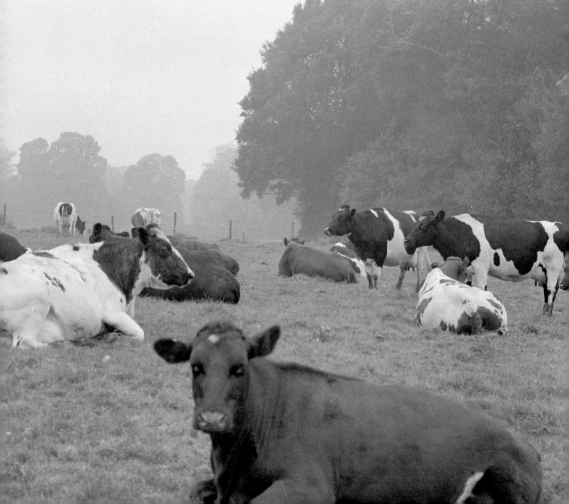

Above and below: More agricultural scenes. (© Historic England Archive; Historic England Archive)

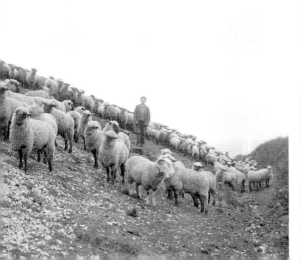

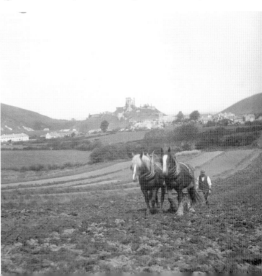

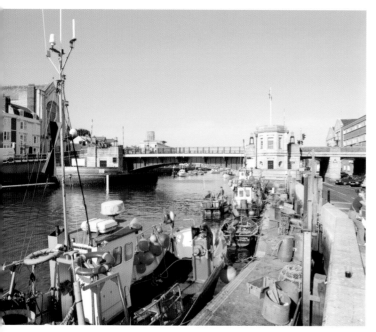

Left and below: Fishing
Around 300 commercial
fishing boats operate out of
Dorset ports, and the fishing
industry is a key facet of the
region. The catch mainly
consists of cod, flatfish, crab,
lobster and shellfish such as
scallops. However, the industry
has experienced something
of a decline in Dorset due
to competition from larger
vessels, increased regulation,
and a lack of young people
joining the sector.

These images show the
inshore fleet at Weymouth,
which has a well-established
potting and netting fishery. (©
Historic England Archive)

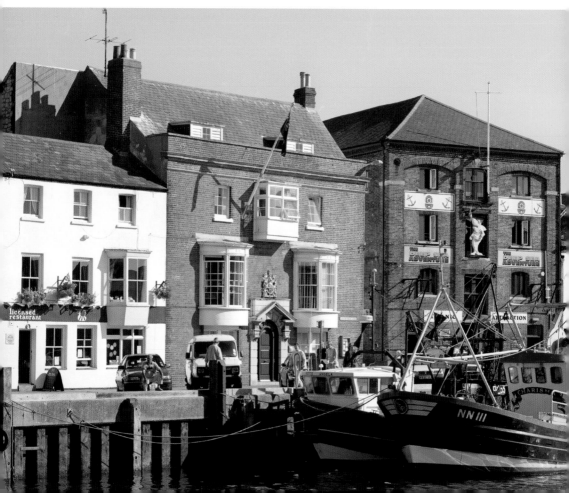

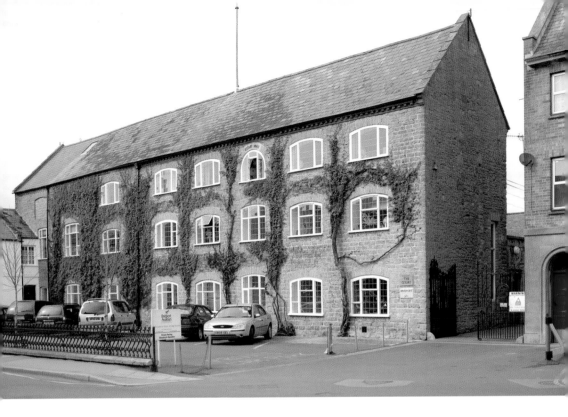

Rope Making

Bridport is the main centre in Dorset for rope making, and as far back as the fifteenth century, Henry VII decreed that all hemp grown within a 5-mile radius should be used for rope making for the Royal Navy. The town was the world's premier centre for rope and net making for 700 years, and the vast width of many of Bridport's streets gives an indication of their former use as rope walks, where long strands of hemp were laid down and then weaved into ropes.

The rope was also used for hangmen's nooses, and a colloquialism to describe someone being hanged was to say that they were stabbed with a 'Bridport dagger'.

Today Bridport still has a handful of companies supplying top quality rope and nets to fishing fleets and sports clubs. Bridport nets are used at Wimbledon and even on the Space Shuttle.

This image shows the exterior of Court Mills factory. (© Historic England Archive)

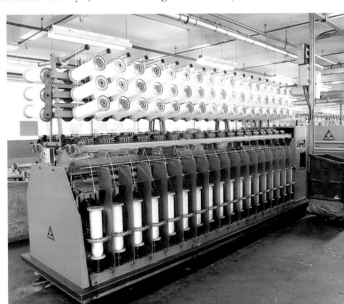

Modern Machinery at Court Mills
This machine is used for weaving threads into one. (© Historic England Archive)

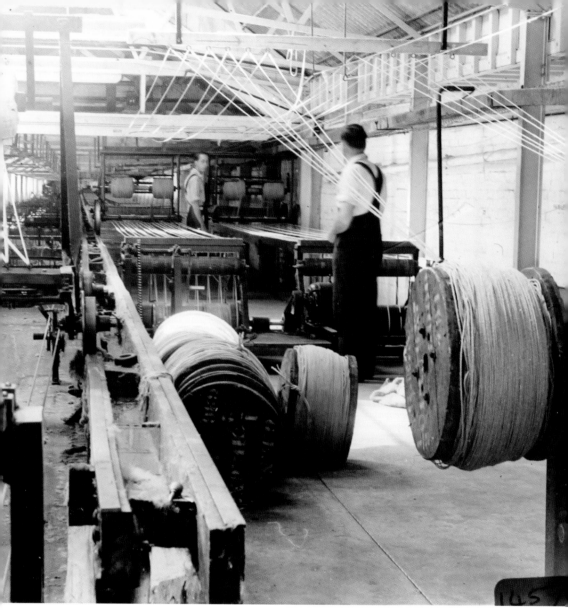

Above: Long House
An interior view of the long house for running out rope as used in the 1940s and 1950s. (© Historic England Archive)

Left: Rope Walk
A view of a former rope walk. (© Historic England Archive)

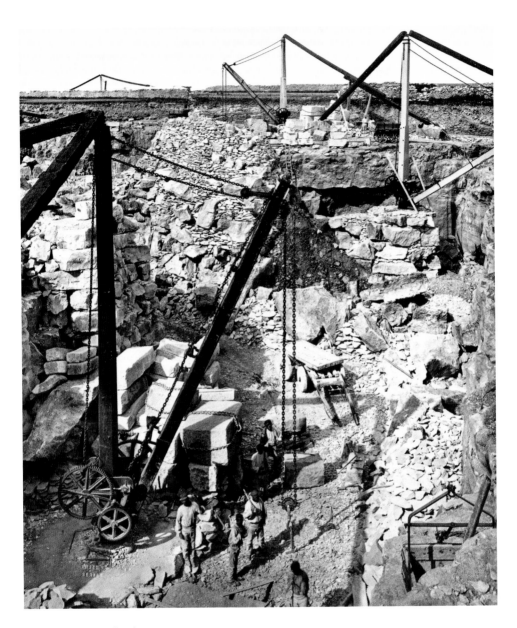

Quarrying in Portland

Portland stone has the qualities of being extremely durable and yet easy to work with. Christopher Wren certainly liked it. In 1978, Victoria Square, Portland, was the scene of a ceremony in which the governor of the Tower of London, accompanied by several beefeaters, unveiled a ceremonial piece of Portland stone to celebrate 900 years of quarrying in Portland, and the fact that the Tower of London was the first building of national significance to use it. Since then, Portland stone has been used in many public buildings including Buckingham Palace and St Paul's Cathedral.

Many of the quarries are still active today, and with new technology pioneered in Portland, they are busier than ever as the stone is still in demand throughout the world.

This image shows some quarrymen in Portland in the late nineteenth century. (Historic England Archive)

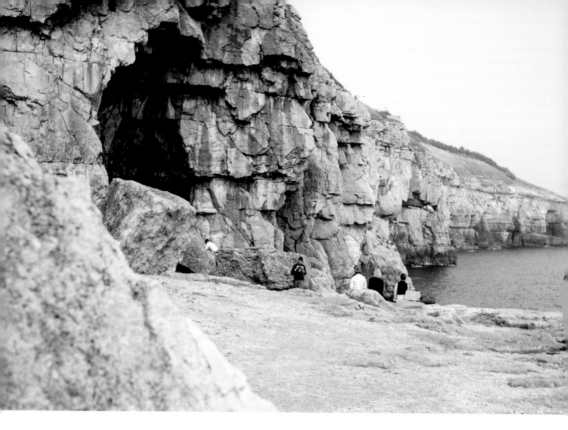

Above: Quarrying in the Purbecks

The Purbeck area around Swanage and Worth Matravers is also renowned for quarrying. Limestone has been quarried here since Roman times, reaching a peak in the eighteenth and nineteenth centuries, when it was shipped to London in vast quantities.

The founding fathers of Swanage, John Mowlem and his nephew George Burt, were central to the development of the industry.

Burt had a penchant for rescuing old buildings in London and bringing them to life again in Swanage. Swanage Town Hall is an example of this, having been Mercer's Hall in Cheapside, London, in a previous life.

Today, Purbeck stone is still quarried using opencast methods. The image shows the entrance to Tilly Whim Caves at Durlston Head, which were mainly worked in the eighteenth century. The stone was hauled into ships waiting on the coast, using a wooden crane, known as a 'whim', hence the name of these caves, named after a quarryman, George Tilly.

George Burt opened them up as a tourist attraction after the quarrying ceased, but they were closed down in 1975 after a rockfall. (© Historic England Archive)

Opposite above: Tourism

With many miles of beautiful beaches and unspoilt countryside, Dorset has a lot going for it as a tourist destination, and tourism is a major factor in the county's economy. This aerial view shows the coast from Boscombe to Poole. (© Historic England Archive. Aerofilms Collection)

Opposite below: Bournemouth Pier

Bournemouth was announced as the winner of the best UK seaside town in the prestigious 2019 British Travel Award. (© Historic England Archive)

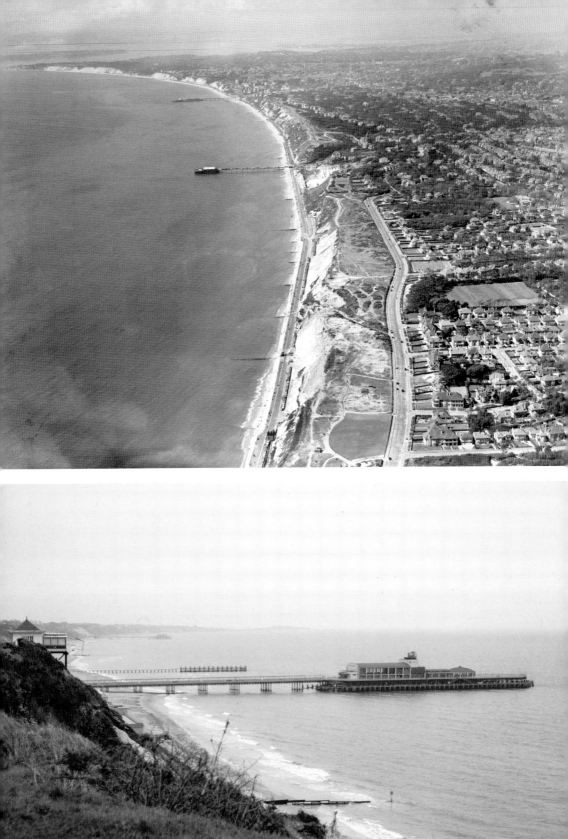

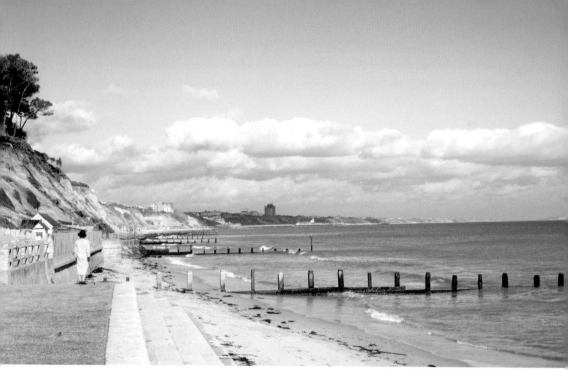

Above: Flaghead Chine
Flaghead Chine, Canford Cliffs, Poole. (© Historic England Archive)

Below: Weymouth Beach
Sun worshippers at Weymouth Beach. (© Historic England Archive)

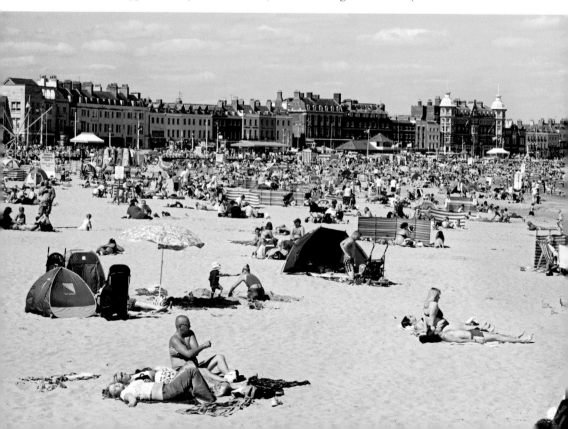

Pubs and Hotels

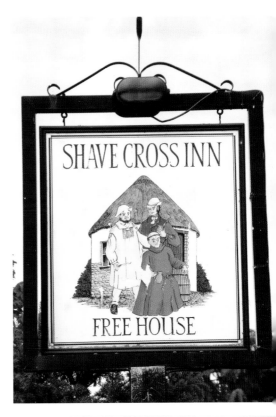

Right and below: Shave Cross Inn, Marshwood
The Shave Cross Inn dates from the thirteenth century. It is situated at the Shave Cross roundabout in the small hamlet of Shave Cross, which is in the picturesque Marshwood Vale. The pub still retains a medieval skittle alley and flagstone fireplace.

This crossroads was a stopping place for pilgrims on their way to St Wite's Shrine in the nearby hamlet of Whitchurch Canonicorum (see Saints, Martyrs, Abbeys, Priories, Minsters, Monastic Churches and Others).

They stopped to have their heads shaved as an act of religious humility. The exact medieval term for the practice was called tonsuring, and could involve shearing of all, or part, of the scalp. The practice is still carried out in some specific religious orders, and is a traditional practice in Islam after the completion of Hajj.

The images show the pub sign and thatched skittle alley. (© Historic England Archive)

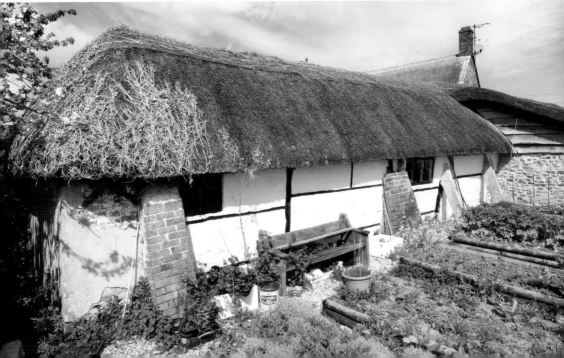

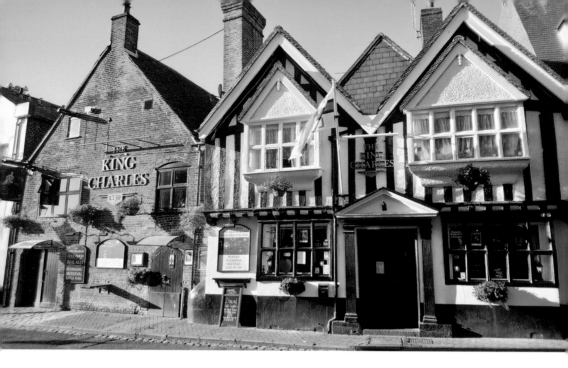

Above: King Charles, Poole

The King Charles first became an alehouse in 1770. However, a section of the pub known as the King's Hall dates back to 1350.

The King's Hall was originally part of one large building known as the Town Cellars or Wool House (see Wool House). The building became divided in the eighteenth century, as it was cut through in order to provide a thoroughfare for fish and other commodities to roll through on carts bound for markets in other Dorset towns and London. This became known as Thames Street due to its London connection and provided an access route from the Quay to the High Street.

The main section of the pub dates back to Tudor times including much of the brickwork and oriel panelling, while some of it is from the later Jacobean period. The older King's Hall section retains the original roof beams and fireplace.

The name changed to the King Charles in the early 1900s in recognition of the exiled French king Charles X landing at Hamworthy on the other side of Poole Quay in 1830. (Author's collection)

Opposite above: Wool House, Poole

Poole prospered during the fourteenth century due to trade with Bordeaux in France, which at the time belonged to the English Crown. This allowed Poole to overhaul Wareham as the premier port and major town in the area and become Dorset's Port of the Staple, which meant it was licensed to import and export staple commodities, mainly wool and leather produced in the outlying areas of rural Dorset.

The building that was used to store those commodities was the Wool House. It is considered to be one of the most important surviving medieval port buildings in northern Europe, and the finest surviving example of a wool house in England. It is part of this original building, which is now part of the King Charles pub. The other, larger section now hosts the Local History Centre, which is part of Poole Museum.

The building we see today is a fifteenth-century structure, but this overlies an even older structure dating back to 1350.(© Historic England Archive)

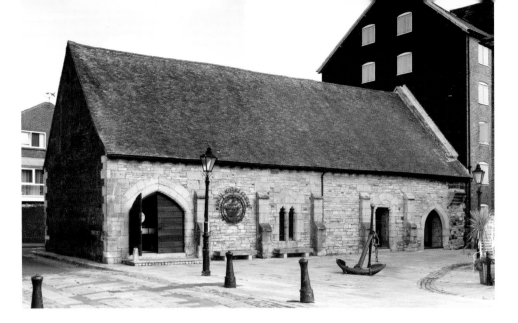

Below: Bankes Arms Hotel, Corfe Castle

The Bankes family were a prominent family of landed gentry in Dorset who owned large tracts of land, including Corfe Castle (see Castles).

They were the owners of the castle at the time of the Civil War and supported the Royalist cause. Lady Bankes held out for many months against a Parliamentarian siege, and the castle was only eventually captured as a result of treachery by one of her own soldiers.

After the Civil War, and the return of the monarchy in the form of King Charles II, the Bankes family rose again, and made their new home at Kingston Lacy near Wimborne.

There are two pubs in the locality using the name of Bankes, the other being the Bankes Arms pub at Studland.

The Bankes Arms Hotel in the village of Corfe Castle is a Grade II listed manor house with a bar and a restaurant. The building dates back to 1549, almost a century before the siege.

This image shows the Greyhound Hotel on the left and the Bankes Arms Hotel on the right (© Historic England Archive; Historic England Archive).

Kings Head, Poole
A pub called the Plume of Feathers, which can be traced back to 1678, was originally at the site of the Kings Head. However, some historians believe there is evidence to show that the Plume of Feathers, which may have been called the Feathers back then, predates the Spanish invasion of Poole by Don Pero Niño in 1405, which was in revenge for the antics of the notorious Poole pirate Harry Paye in Spain.

The pub sign depicts Henry VIII, who is reputed to have stayed at the Plume of Feathers. He used it as a base to check the progress of a castle he was having built to defend the strategic position of the harbour entrance at Brownsea Island (see Castles).

The pub was a notorious smugglers' haunt, and smugglers' passageways were found during restoration work. The notorious Carter Gang of Poole hid their goods in this pub. One of the tunnels leads to the Quay and another leads to St James's Close near St James's Church (see Saints, Martyrs, Abbeys, Priories, Ministers, Monastic Churches and Others). (Author's collection)

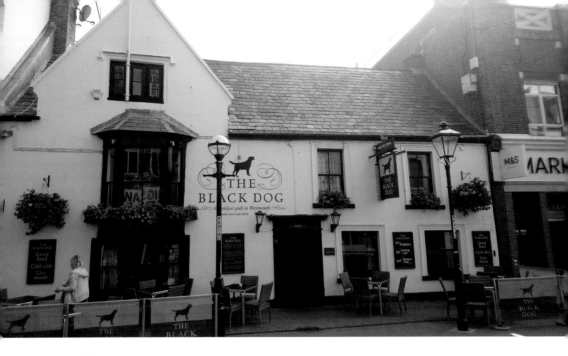

Black Dog, Weymouth

Built in the sixteenth century, the Black Dog is one of the oldest pubs in Weymouth. The pub was originally called the Dove, but changed its name when Weymouth, like Poole and other towns in the South West, were involved in trading with the newly formed colonies of Newfoundland and Labrador.

It was during this time that the landlord of this pub purchased one of the first black Newfoundland dogs ever seen in this part of the country from one of the new trading ships. The local legend is that the dog attracted such a vast number of sightseers from the surrounding district that the landlord changed the name of the pub in honour of his new-found prosperity.

The pub is also known to be an old smuggling haunt, and in 1758 Richard Hawkins was whipped to death by the infamous Hawkhurst smuggling gang from the Sussex/Kent border, who had falsely accused him of an offence against the gang. The gang members were later caught and hanged at East Grinstead. (Author's collection)

George Hotel, Charmouth
This photograph shows a horse-drawn cart laden with faggots standing outside the George Hotel. It is a Grade II listed building, which was formerly a coaching inn in the seventeenth, eighteenth and nineteenth centuries. The core of the roof dates back to the sixteenth century. (Historic England Archive)

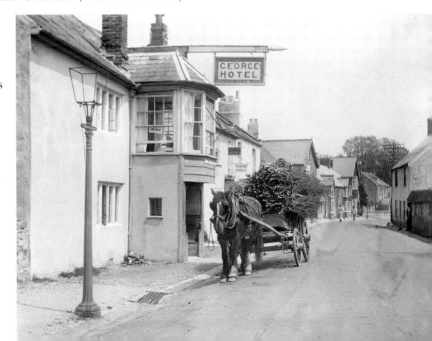

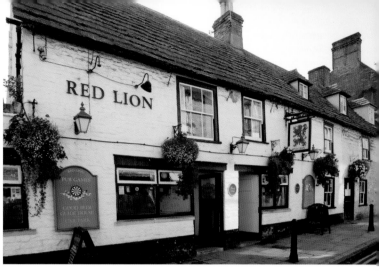

Above left and above right: Red Lion, Swanage
The Red Lion at Swanage is a former nineteenth-century coaching house. (© Historic England Archive)

Below: Kings Head Hotel, Wimborne Minster
This eighteenth-century, three-star hotel, which contains twenty-seven en-suite bedrooms, is an imposing building that dominates Wimborne Square. The hotel was first mentioned in 1726, but in 1848 the premises were owned by Thomas Laing, and it was known as Laing's Hotel. As well as being a hotel, it also operated as a posting house, where horses were kept for hire to be used by mail coaches.

In 1889, the new owner, William Ellis, had the hotel rebuilt after a fire and renamed it the Kings Head Hotel. The painted sign depicts King Henry VII, who is associated with Wimborne through his mother, Lady Margaret Beaufort, who was an influential figure in the Wars of the Roses and in bringing the crown to the Tudors. She was brought up at Wimborne's Kingston Lacy House, and in 1497 included a provision in her will that the people of Wimborne should be provided with a free school.

In 1563, Queen Elizabeth I ratified the provision on the condition that the school was named after her. The school was originally a grammar school, but is now a comprehensive at a different site. However, it still retains the original name of Queen Elizabeth's School. (Author's collection)

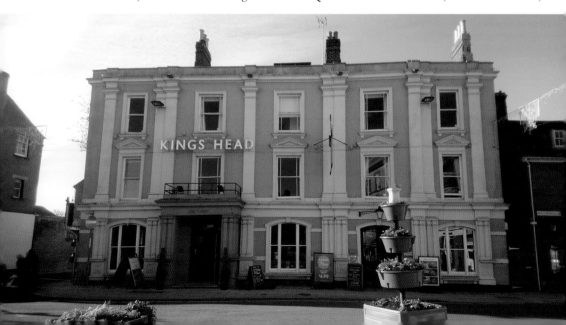

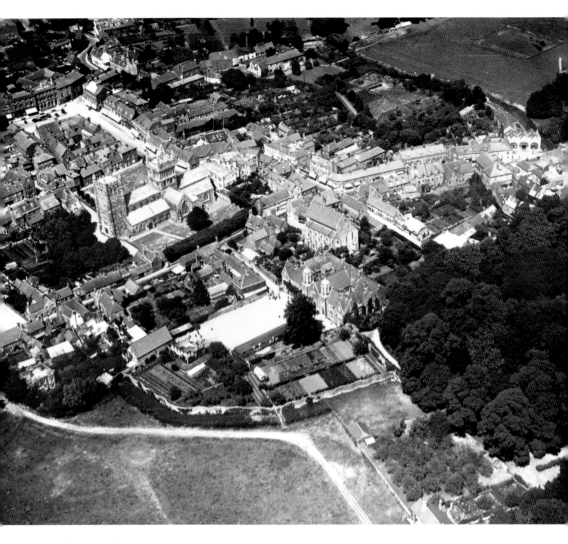

Queen Elizabeth Grammar School
The aerial image shows the original Queen Elizabeth Grammar School, which is still standing in Wimborne. (© Historic England Archive. Aerofilms Collection)

Saints, Martyrs, Abbeys, Priories, Minsters, Monastic Churches and Others

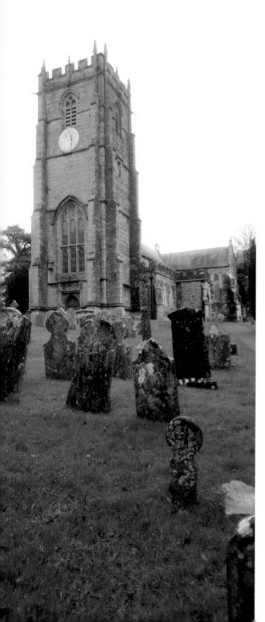

The Church of St Candida and Holy Cross, Whitworth Canonicorum

The parish church in Whitworth Canonicorum is sometimes referred to as the Cathedral of the Vale, and the name of the village means 'Church of St Wite belonging to the canons', the canons being the canons of Salisbury Cathedral, who owned the manor house in the village.

The church is dedicated to St Wite, also known as St Candida, who was apparently a Christian Saxon hermit who would act as a coastguard and also helped travellers. She was murdered by the marauding, raping and pillaging Danes in AD 831 when they came ashore at Charmouth.

Later, King Alfred the Great made her a saint in recognition of the fact that she had died for her faith, and in AD 890 he had a chapel built in her honour where the church now stands.

In the twelfth century, after the church had been rebuilt, a shrine in which her bones were interred was constructed. It consisted of three openings, through which people could, and still can, thrust parts of their body in order to be healed, as she was regarded as a healer and had lived near a spring where the water was said to have healing properties. At one time this church was second only to Canterbury as a site for pilgrims to visit, and the task was made less arduous by the fact that all footpaths in the Marshwood Vale led to the church.

The white cross within the yellow background of the Dorset flag is that of St Wite.

The saint is in good company at Whitchurch Canonicorum, as also laid to rest in the churchyard is Robin Day, the TV political interviewer of the 1970s, who was much impersonated by Mike Yarwood. His tombstone reads, 'In loving memory of Sir Robin Day, the grand inquisitor'.

Another famous body residing in the churchyard is that of Bulgarian defector Georgi Markov, who was prodded in the leg with a poison-tipped umbrella by an assassin masquerading as a city gent on Waterloo Bridge, London, in 1978. (Author's collection)

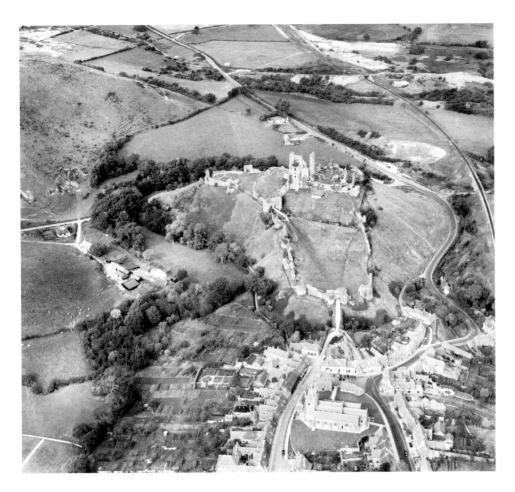

St Edward's Church

Edward, king and martyr (r. 975–78), visited Corfe Castle on 18 March 978. The fifteen-year-old king arrived on horseback and was welcomed with a goblet of wine. He was just enjoying his first few sips, still astride the horse, when he was murdered. It is thought that the order for his murder probably came from his stepmother, who wanted to place her own son, Ethelred (the Unready), on the throne. The horse bolted and dragged Edward's lifeless body along before finally dislodging him into a stream.

Legend has it that a poor blind woman took the body to her cottage nearby, where she covered it with rough clothing. Later in the night, the cottage was filled with a bright light, and the woman's sight was restored. It is said that St Edward's Church in the village of Corfe Castle was built where the old lady's cottage was situated.

Edward was initially buried at Wareham, but the occurrence of further miracles at the site of his burial, caused him to become recognised as a saint and martyr. His remains were removed to Shaftesbury Abbey, which also became a place of pilgrimage. Shaftesbury Abbey was destroyed in Henry VIII's Dissolution of the Monasteries in 1539, but the bones of the saint were hidden and avoided desecration.

In 1931, an archaeological excavation found them, and the relics were donated to the St Edward the Martyr Orthodox Church in Woking, Surrey.

The aerial view is of both Corfe Castle and St Edward's Church. (© Historic England Archive. Aerofilms Collection)

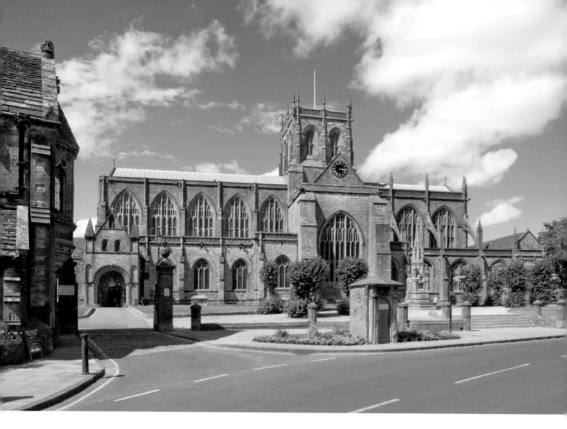

Sherborne Abbey

Sherborne Abbey was originally a Saxon cathedral and is the burial place of two Saxon kings of Wessex: Ethelbald (r. 858–60) and Ethelbert (r. 860–65), both of whom were older brothers of Alfred the Great.

In 705, St Aldhelm was the inaugural bishop and was followed by twenty-seven successors, with the twenty-seventh becoming the first Bishop of Salisbury, as, by then, William the Conqueror had conferred the cathedral status on Salisbury, as Sherborne was too far west to keep under his control.

Sherborne then became an abbey, but after the Dissolution of the Monasteries, the people of Sherborne were able to use the abbey as their parish church, and what had been the monks' residential area became Sherborne School in 1550. (© Historic England Archive)

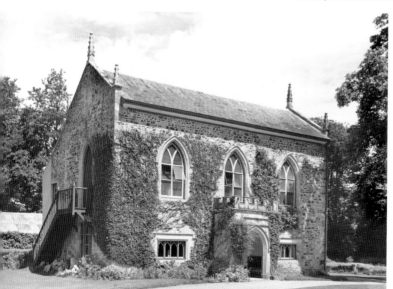

Bindon Abbey

Bindon Abbey, near Wool, was a Cistercian monastery founded in 1149 by William de Glastonia. The remains of the abbey are now part of an eighteenth-century private stately home, which is used as a wellness retreat. (Historic England Archive)

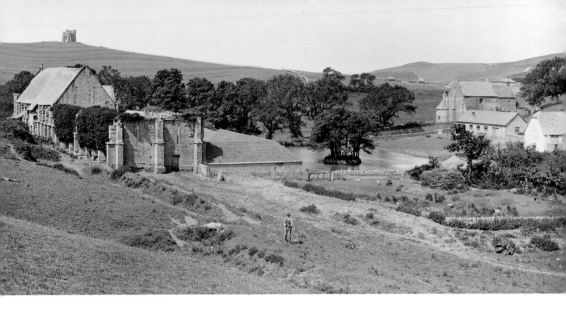

Above and below: Abbotsbury Abbey

Abbotsbury Abbey was a thriving Benedictine monastery, but all that remains now are a few ruins, a chapel and a tithe barn. It was originally dedicated to St Peter as a Benedictine monastery and was founded in the eleventh century by King Cnut.

The St Catherine's Chapel part of the monastery, which is now a Grade I listed building, survived the Dissolution, as it is situated on a hilltop slightly distant as a pilgrimage chapel. However, it nearly didn't survive a siege in 1644 during which Cromwell's troops inflicted severe damage.

The barn, which was built in around 1400, was considered to be the largest thatched barn in England and was reputedly used by smugglers. The images show the barn and a sketch of how the abbey may have looked before the Dissolution of the Monasteries. (Historic England Archive; © Historic England Archive)

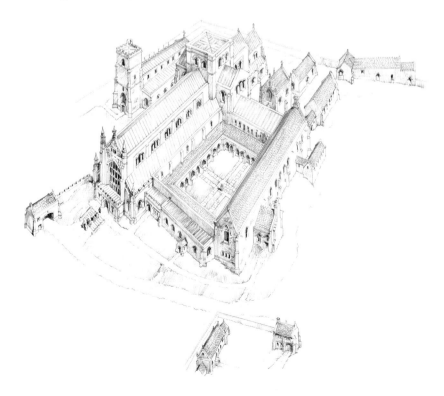

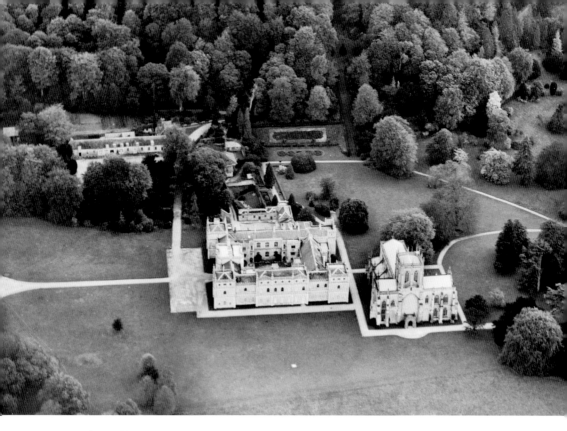

Milton Abbey

The original abbey was founded around 933 by King Athelstan of Wessex, who also placed sixteen Dorset manors under the abbey's control. Then In 964, King Edgar dismissed the secular priests, and replaced them with Benedictine monks from Glastonbury.

After the Dissolution of the Monasteries in 1539, the monks were ejected and the manors and properties were sold to the lawyer who had arranged Henry VIII's divorce from Catherine of Aragon.

In 1779, the autocratic owner of the property did not relish having the common villagers of Middleton on his doorstep. He destroyed the houses as the leases became due or the occupants moved and instead created the village of Milton Abbas, which was further away and meant he no longer had to hear the villagers annoying antics.

In 1953, the mansion and grounds were bought by a trust to establish Milton Abbas School. The image shows an aerial view of Milton Abbey and the abbey church in 1933. (© Historic England Archive. Aerofilms Collection)

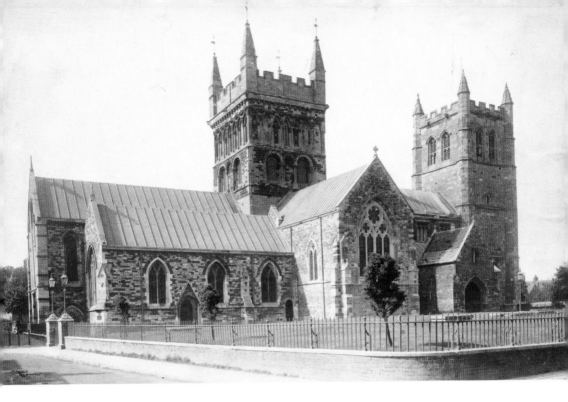

Wimborne Minster

Wimborne Minster is colloquially known by the same name as the town. However, the church should more correctly be termed the Minster Church of St Cuthburga, as it is dedicated to St Cuthburga, sister of King Ina, who was King of the West Saxons from 658 to 726. It is the only church in existence dedicated to that saint.

Wimborne Minster is the resting place for two kings and one queen: Queen Cuthburga, who married the King of Northumbria; King Ethelred, who was killed in 871 in a battle with the Danes nearby; and King Sifferth, a Danish king who died in 962.

In 705, St Cuthburga founded a Benedictine nunnery on this site, and 500 of the nuns were reputedly recruited from here by St Boniface and sent to Germany to convert the pagan hordes.

The nunnery was destroyed by the Danes in 1013, and the present building dates from around 1120.

In 1043 Edward the Confessor established a college of secular canons, who ministered to the surrounding area, which is why the church is called a minster. (Historic England Archive)

Chained Library

The minster also possesses a chained library, which was founded in 1686, and was one of the first public libraries in the country. (Historic England Archive)

Left: Astronomical Clock and
Quarter Jack
The minster is famous for a
mechanical soldier, known as the
'Quarter Jack', who resides on the
West Tower and strikes a bell every
quarter of an hour. He was originally
a monk, but became a soldier during
the Napoleonic Wars. There is also
an astronomical clock, which is
thought to date from the 1300s and is
connected to the Quarter Jack and still
keeps good time. It also informs the
position and phase of the moon. The
image shows the astronomical clock.
(Historic England Archive)

Below left: Wimborne Minster
An interior view of Wimborne
Minster. (Historic England Archive)

Below right: Eagle Lectern
The eagle on whose outstretched
wings a bible can be placed is notable
for its mother-of-pearl eyes. (Historic
England Archive)

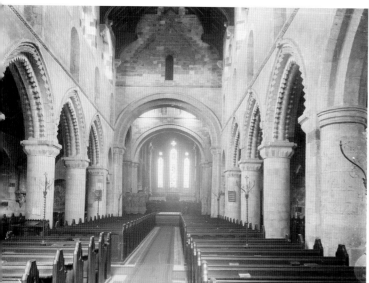

Cerne Abbey
A Benedictine abbey, reputedly founded by St Augustine, was established at Cerne Abbas in AD 987, but all that remains of the abbey now is the abbot's porch and the tithe barn shown in the picture. (Historic England Archive)

Christchurch Priory
Before the Normans arrived, the town of Christchurch was called Twyneham, a Saxon word that signified the meeting of two rivers – the Stour and the Avon. In 1094, at the instigation of Ranulf Flambard, the most powerful and feared baron in England, the Normans set about building a large and imposing church at St Catherine's Hill, a mile away from the site of the original Saxon church.

However, legend has it that they were beset by problems of material going missing overnight, only for it to turn up at the site of the original church in the morning. It seemed that God was moving in mysterious ways, indicating that the site should be at the original church. A further indication came when construction was eventually moved to the original site, and a mysterious extra-curricular carpenter, who wasn't on the payroll, joined the workers.

On one occasion a huge wooden beam was cut too short and therefore wouldn't fit into its intended position. However, the following day the beam was miraculously the correct size and had been slotted into place. The enigmatic mystery man had also disappeared, confirming the builder's suspicions that the mystery man must have been a certain well-known carpenter from Nazareth. This story spread far and near, and the church became known as Christ's Church, which led eventually to the town also being called Christchurch.

When King Rufus died, his successor, Henry I, had Flambard imprisoned in the Tower of London as the first ever 'guest' of that establishment. However, Flambard managed to escape by having a barrel of wine delivered to him with a rope inside. He got his captors drunk, and then used the rope to scale the walls. This scene is depicted in the grounds next to the priory. (Historic England Archive)

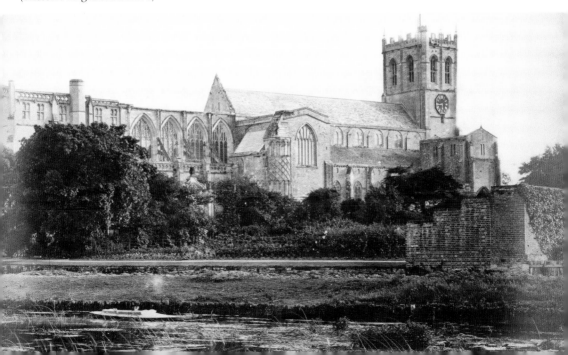

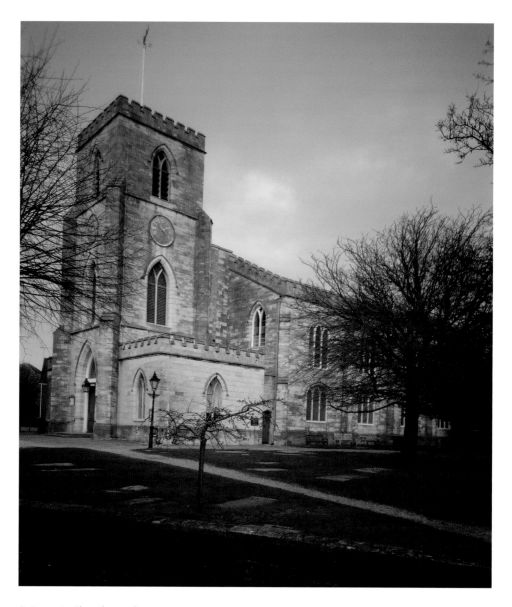

St James's Church, Poole

St James's Church was originally built in 1142, but was demolished and rebuilt in 1819. Contained within are columns constructed from Newfoundland pine, which were brought to Poole by the local merchants involved in trade with Newfoundland. At the top of one of the columns is a Newfoundland and Labrador flag, which celebrates the long-held connection between Poole and Newfoundland.

Other interesting flags that can be seen in the church include the Union Jack, which was the first British flag to fly in Paris after that city's liberation by the Allies in 1945. It was donated by Cdr Tom Sherrin, a former Mayor of Poole.

There is also an American flag that flew on a US coastguard cutter that took part in the D-Day landings. (Author's collection)

Bibliography

Belasco, S., *Dorset from the Sea* (www.veloce.co.uk, 2015)

Hilliam, D., The *Little Book of Dorset* (History Press, 2010)

Jackson, A., *Poole Pubs* (Amberley Publishing, 2019)

Jenner, L., *The Monmouth Rebellion and the Battle of Sedgemoor* (Somerset County Council Heritage Service, 2017)

Syer, E., *A Guide to the Church of Saint Candida and Holy Cross Whitchurch Canonicorum* (Creeds the Printers, 2005)

Tincey, J., *Sedgemoor 1685: Marlborough's First Victory* (Pen and Sword Military Publishing, 2005)

Waters, C., *Who Was St Wite?* (Creeds the Printers, 1980)

Westwood, R., *Fossils and Rocks of the Jurassic Coast* (Inspiring Places Publishing, 2018)

Westwood, R., *The Tyneham Story* (Inspiring Places, 2017)

Enid Blyton Trail Dorset

Highcliffe Castle – visitor information leaflet

Nothe Forte – visitor information leaflet

Ricketts, E. St Ann's Church, Radipole, Weymouth. A short guide for visitors

Sherborne Castle visitor information and map

The Minster Church of St Cuthburga, Wimborne Minster, Dorset

Tolpuddle Martyrs Museum

Wareham Town Museum

www.archaeologytravel.com

www.bankesarmshotel.co.uk

www.britainexpress.com

www.dorsetlife.co.uk

www.englishheritage.co.uk

www.historicengland.org.uk

www.jurassiccoast.com

www.jurassiccoast.org

www.resortdorset.com

www.visitdorset.com

About the Archive

Many of the images in this volume come from the Historic England Archive, which holds over 12 million photographs, drawings, plans and documents covering England's archaeology, architecture, social and local history.

The photographic collections include prints from the earliest days of photography to today's high-resolution digital images. Subjects range from Neolithic flint mines and medieval churches to art deco cinemas and 1980s shopping centres. The collection is a vivid record both of buildings that are still part of everyday life – places of work, leisure and worship – and those lost long ago, surviving only in fragile prints or glass-plate negatives.

Six million aerial photographs offer a unique and fascinating view of the transformation of England's towns, cities, coast and countryside from 1919 onwards. Highlights include the pioneering photography of Aerofilms, and the comprehensive survey of England captured by the RAF after the Second World War.

Plans, drawings and reports provide further context and reconstruction artworks bring archaeological sites and historic buildings to life.

The collections are housed in a purpose-built environmentally controlled store in Swindon, which provides the best conditions to preserve archive items for future generations to enjoy. You can search our catalogue online, see and buy copies of our images, as well as visiting our public search room by appointment.

Find out more about us at HistoricEngland.org.uk/Photos
email: archive@historicengland.org.uk
tel.: 01793 414600

The Historic England offices and archive store in Swindon from the air, 2007.